COLLAGE PAINT DRAW

EXPLORE MIXED MEDIA
TECHNIQUES & MATERIALS

SUE PELLETIER

NORTH LIGHT BOOKS
CINCINNATI, OHIO
artistsnetwork.com

CONTENTS

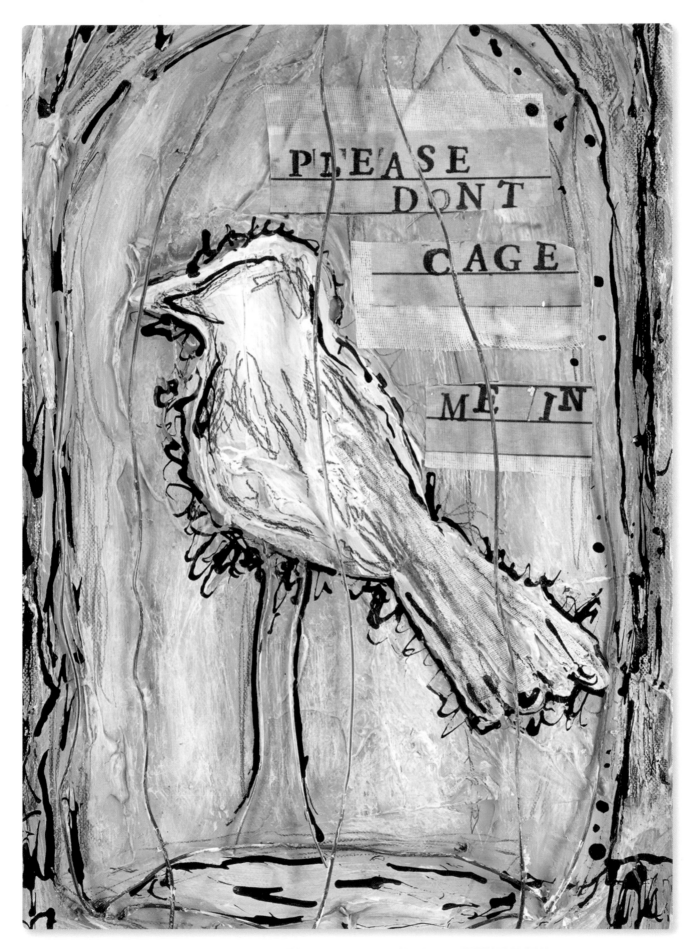

MATERIALS LIST

PAPER

140-lb. (300gsm) hot-pressed watercolor paper

assorted decorative paper

carbon paper

gold leaf paper

newsprint

sheet music

tissue paper

vintage book pages

vintage letter tiles

vintage pattern paper

FABRIC

burlap

canvas

cheesecloth

crinoline

lace

scrim

TOOLS

awl

label maker

palette knife

pipette

plastic icing dispenser

scissors

tracing wheel

X-acto or craft knife

DRAWING/PAINTING

assorted acrylic glazes

assorted acrylic paints

assorted fabric paint

assorted gesso

assorted inks

black ink pad

chalkboard paint

chalk marker

glitter glaze

graphite crayons

liquid watercolors

masking fluid

pencil

permanent markers

water-soluble oil paints

water-soluble oil pastels

MISCELLANEOUS

acrylic ground medium

art plaster

assorted stencils from StencilGirl Products

beeswax

bleach pen

braille

cardboard

chunky glitter

clothespins

disappearing glue stick

dryer sheets

fabric stiffener

foam core

heavy matte gel medium

HVAC tape

letter stamps

Liquid Nails

modeling paste

packing tape

Paperclay

paper towels

Paris Craft

sludge

small skillet

small wire hangers

tacky glue

texture additive

tile tape

vintage buttons

vintage doll clothes

wire

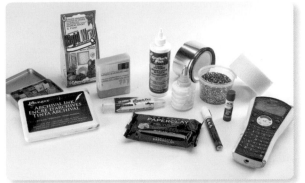

INTRODUCTION

I have come to realize as an artist that whatever I paint has to come from my soul, which is why my imagery is often similar: the house, a bird, a childhood dress, a Mary Jane shoe, numbers, chairs, ladders. They're all images that I hold near and dear to myself and to the day-to-day journey of life. These images remind me of my own childhood and my role as a mother, artist and teacher. You paint what you love, and love what you paint.

My artwork is full of layers: fabric, paint and mediums to build up surfaces with rich texture. I like to create the unexpected. My life is full of layers, too: my children, my home, humor and creating art. In art and life there is more than just what's on the surface. I am drawn to painterly, rich textural surfaces created with paints, mediums or collage materials and am blissfully happy when I can combine any of those in creating a piece of art. My work has a colorful, playful vibe to it. However, often there is a grittiness mixed in to a part of the painting. For instance, the way I outline something or go back into a piece with a pencil and scribble on paint or raw canvas. I love the juxtaposition of working like this, sweet but often with an edge. Shake things up with your artwork; don't always do what feels totally comfortable. Try to push yourself in new directions while remaining comfortable and true to yourself as an artist.

I totally believe in the aha moment, when you see something in a different way or different light. Perhaps some of this goes hand and hand with the fact that I have been teaching elementary school art for twenty-five years. Children are continually coming up with new ways to do things. I believe adults can, too. I believe it has not all been done before, so it's valuable to play, experiment and play some more. The spontaneity and expression in children's art has always been a source of inspiration. Self-discovery and play are vital to my work.

I am fascinated by 3-D and 2-D work. I love to work with plaster, mediums, wax, etc. and combine these surfaces with paint, wire, nails and fabric. My go-to art supplies are heavy matte gel medium and modeling paste. Give me both of those materials and a kindergarten pencil, and I am pretty much all set for the day! Getting messy is blissful to me. Large hardware stores hold a plethora of ideas for combining materials. Wander the aisles and look for nontraditional art materials.

I hope you will look at the techniques in this book as a starting point for your own work. You can also pick bits and pieces from projects and combine them in a fresh way that works for you. The imagery in this book and the words I use in my art are a huge part of who I am. Maybe some of this imagery will ring true to you. Perhaps it will get you thinking about what to paint, which I believe is more important than knowing how to paint. I believe you should paint what you love. If you do, the sincerity will come through loud and clear.

I do a lot of writing, and in my work I use words that are often humorous or quirky. I'll think of a saying or a word and use that as a starting off point for a new painting.

Freeing yourself up when you are painting is very important. In this book some projects are smack-dab in your face, and others are subtle. I feel that all of these projects will push you in new directions and hopefully inspire new projects as well. Let yourself play and experiment while you create. Part of the magic happens when you discover new ways to use materials. If something does not work, it's OK. Move on and try something new.

Breathe, laugh out loud, play and create from your heart.

—Sue Pelletier

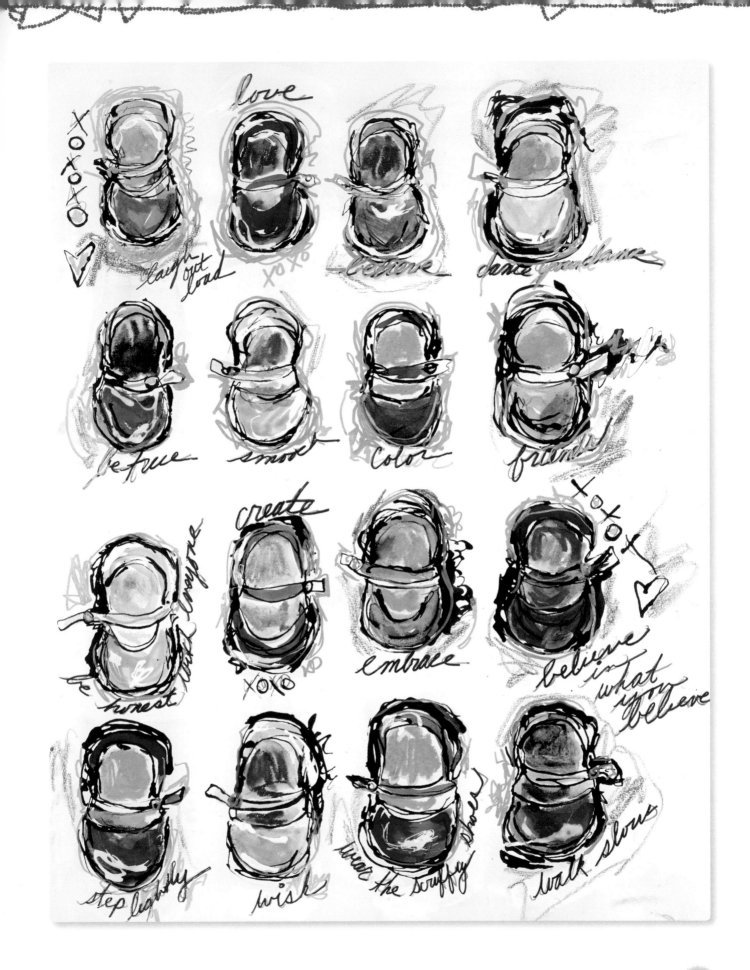

DRAWING WITH A SPLASH OF COLOR

Think of your drawing as the blueprint for your mixed-media pieces. It is the start, where you begin. However, it does not need to be overwhelming. Keep things loose. Keep things gestural. Keep it simple. Everything you draw can be broken down into simple shapes. As an artist you need to put those shapes together so they make sense to *you*. Drawing may be your first step in creating a piece of mixed-media art; however, the beautiful thing about mixed media is that there are always ways to layer and change your images as you work. When you begin a piece and you have that first mark-making experience, don't overthink it. Just get your mark making on.

I believe in happy accidents and the process of drawing, just as much as the completed piece. Often when I draw, I try to use materials and tools that will purposely prevent me from having total control over what I am drawing. If you draw using ink and an ink dropper, you will end up with a very gestural drawing because you don't have total control over the materials. A drop of ink may puddle and drip. Leave it. If you are using a graphite pencil or crayon to draw and the urge to scribble an outline on your drawing suddenly comes over you, go for it! Among my favorite drawing tools are the chunky soft-lead pencils children use in kindergarten. They allow me the freedom to draw, stress-free, because they are the same tools a five-year-old child uses. It is hard to overthink drawing with a kindergarten pencil.

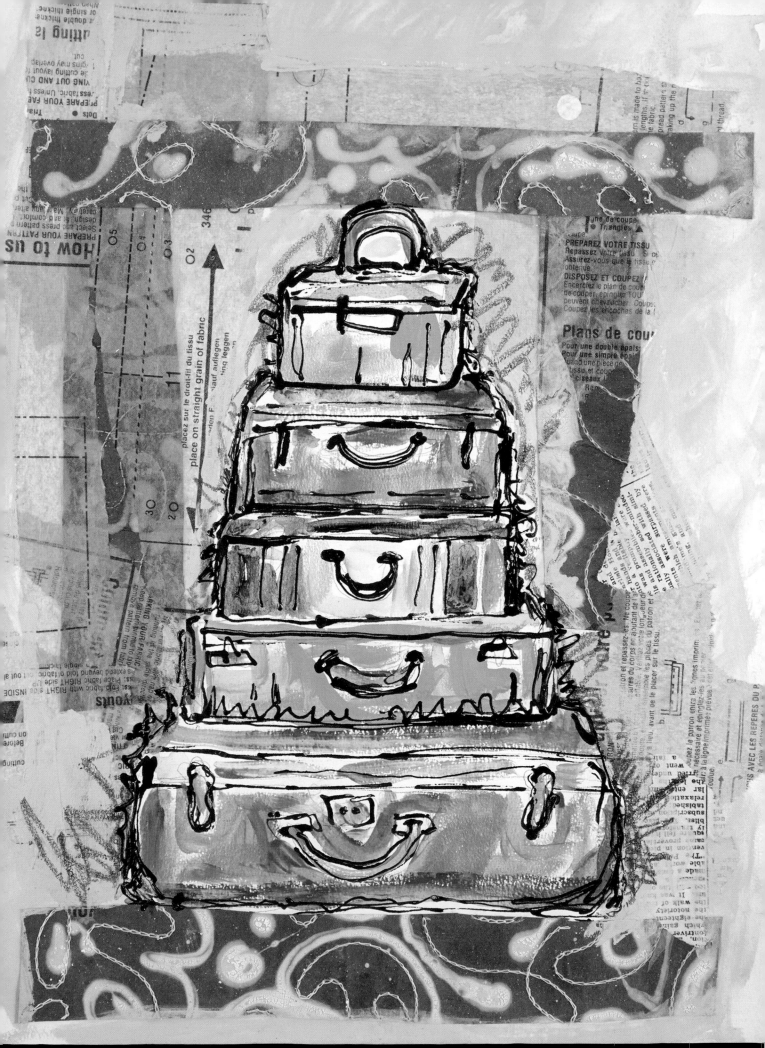

BIRDCAGE DRAWING

Birds show up in my work often. I believe it has to do with not only the pleasing shape of a bird, but also the words that come to mind when I think of a bird: fly, soar, spread your wings. They're all mantras I tend to use daily in my life. The birds in my paintings are usually just a simple contour line drawing of a bird that I go into with graphite, pencil or other mediums to build up the mark making. I usually keep the shape simple and make the bird interesting by creating visual texture.

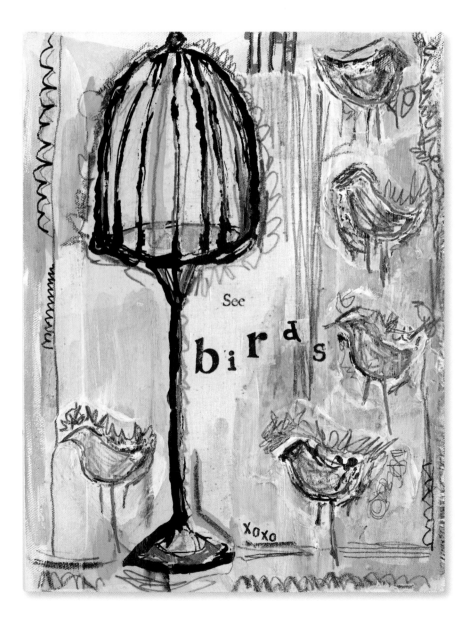

MATERIALS LIST

acrylic paints and brushes

bird stencil

black ink

canvas panel

heavy matte gel medium

metallic permanent marker

modeling paste

pattern paper

pencil

pipette

unprimed canvas strip

vintage letter tiles

water-soluble oil pastels

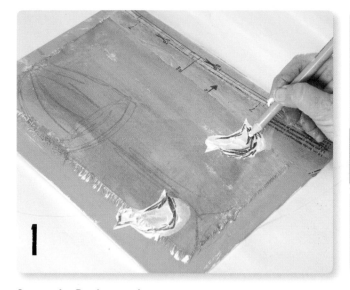

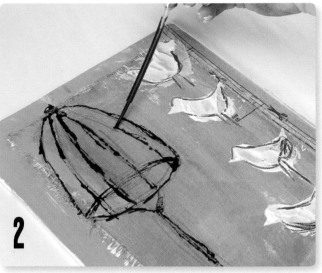

Create the Background Adhere an unprimed canvas strip to a canvas panel. Paint a background with watered-down acrylic. Let dry. For a splash of color and texture, adhere a piece of pattern paper to the canvas with gel medium.

Sketch out the birdcage loosely with a pencil. Use a stencil and modeling paste to create birds. Then add lines into the modeling paste with a pencil.

Draw the Cage Using a pipette, define the birdcage with black ink. The pipette helps keep the lines loose. After the birdcage is defined, add lines of texture and a border to the background with the pipette and ink.

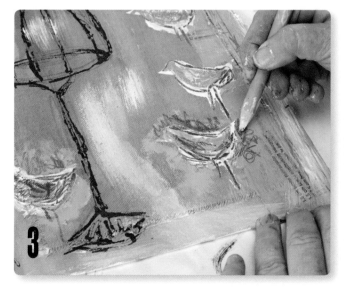

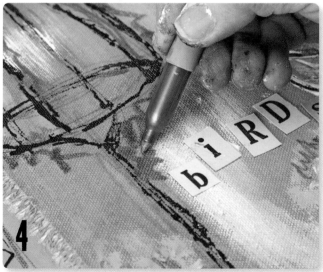

Add Color Add more color to the background and around the birds with water-soluble oil pastels. Draw over and around the birds with a pencil to add more dimension and texture.

Final Details Select the letters you want to use for this piece and adhere them to the canvas with gel medium. Let dry. Finish the piece by adding some shine to the birdcage with a metallic permanent marker.

BLEACH PEN SUITCASES

Vintage suitcases are a passion. I collect them and have them stacked on top of each other in my home. Most of them are filled with found objects and art supplies, which is a great way to store supplies you don't use often. They remind me of a simpler time. I pick suitcases up at yard sales and flea markets and love the fact that they have a history. The bleach pen is great to use here on collaged fabric. It can have a mind of its own, but that's part of the charm.

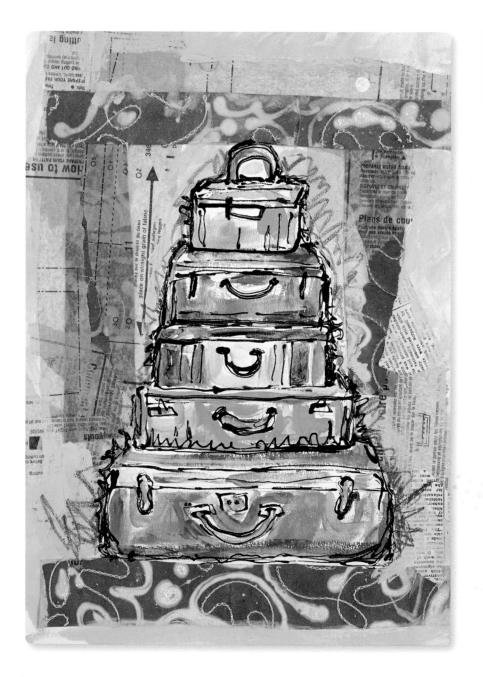

MATERIALS LIST

140-lb. (300gsm) hot-pressed watercolor paper

acrylic paints and brushes

black fabric paint

black ink

bleach pen

fibrous scrapbooking paper with stitching

heavy matte gel medium

metallic permanent marker

pattern paper

pencil

SHE PACKED HER BAGS. SHE WAS WAITING TO SEE WHERE THEY WOULD TAKE HER.

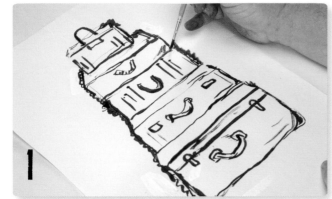

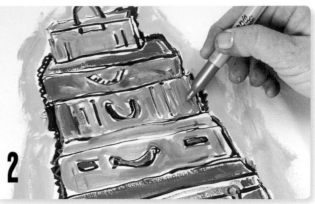

Draw the Suitcases Draw the outline of the suitcase stack with a small brush and black ink. Let dry.

Add Color Add the first layer of color to the suitcases with acrylic paint. Let dry. Use the metallic permanent marker to add details.

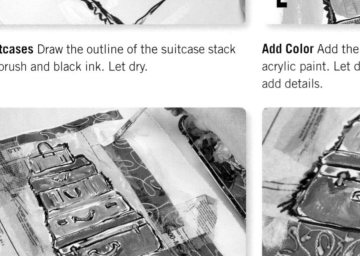

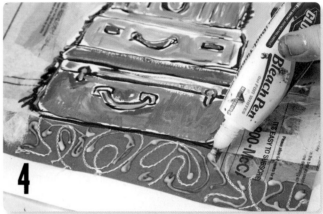

Collage Paper Cut strips of textured paper to collage onto the background. Scrapbook paper is great for this. Adhere the strips to the canvas with heavy matte gel medium. Continue collaging other papers, such as vintage pattern paper, for more texture and interest in the background.

Once the collaged papers are adhered, use acrylic paint to cover the background and parts of the collaged pieces. Let dry.

Add Bleach Pen Doodles Paint doodles and lines onto the collaged paper and suitcases with the bleach pen. Let dry.

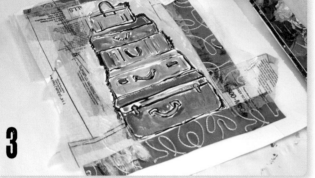

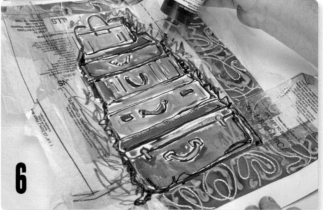

Spread the Bleach Once the bleach is dry, go back with a clean brush and a little water and gently spread the bleach.

Final Details Use black fabric paint to bring out the loose outline of the suitcases. Add lines and texture to the background with a pencil to finish the piece.

SEAL THE HEART WITH BEESWAX

Working on a stretched burlap canvas is a different substrate to work on. Simple imagery works well for this technique. When applying melted beeswax over a piece, I tend not to worry about a perfectly even application. I like the drips and the various thicknesses you can get from beeswax. I also love the fact that while the wax is wet you can stick small bits and pieces, vintage letters and scraps of fabric into the wax.

SHE WAS ODDLY SURPRISED HOW HEARTS KEPT POPPING INTO HER WORK. SHE THOUGHT IT WAS A SIGN SO SHE WENT WITH IT.

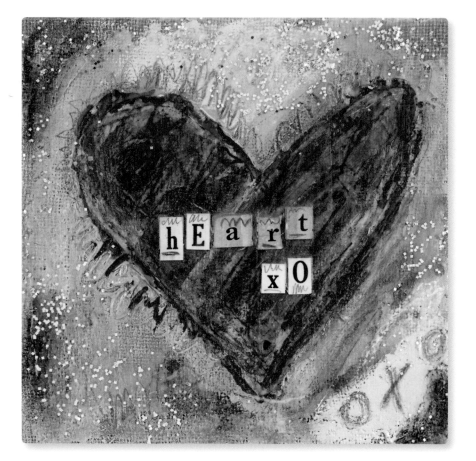

MATERIALS LIST

2" (5cm) chip brush

6B graphite crayon

12" × 12" (30cm × 30cm) stretched burlap canvas

acrylic ground medium for pastels

chalk pastels

chunky glitter (ceiling glitter)

heavy matte gel medium

palette knife

pencil

pure beeswax, chunk

small skillet for melting wax

vintage letter tiles

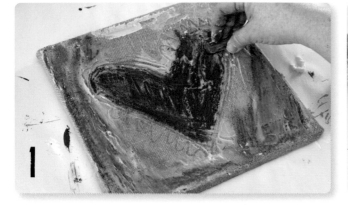

Prep the Canvas and Add Color Use a burlap stretched canvas for this project. Cover the canvas with the acrylic ground medium. Lay it on thick with a palette knife. While the acrylic ground medium is still wet, draw your heart shape with a pencil. Let dry. Then start adding color with chalk pastels, smearing on more acrylic ground to help the pastel pigment stick and seal to the burlap.

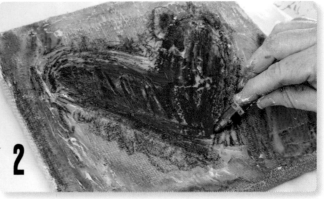

Outline the Heart Outline the heart shape with a 6B graphite crayon. Keep your lines loose and fun. Choose a few letter tiles to spell out your chosen word or phrase, and adhere them to the canvas with the gel medium.

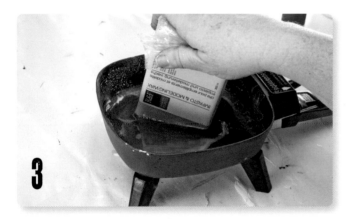

Melt the Wax Melt some of the beeswax in a small skillet. You don't have to melt the whole chunk. Just melt enough wax that you can dip a paintbrush into the liquid.

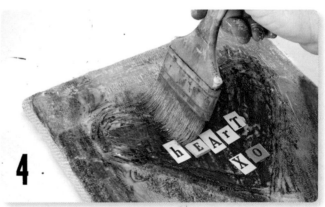

Paint the Canvas With Wax Quickly paint the melted wax onto the canvas with a 2" (5cm) chip brush. Cover the whole canvas with the wax.

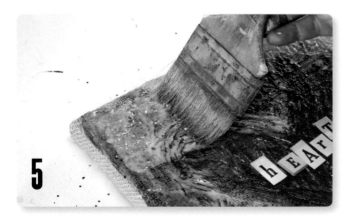

Add Glitter and More Wax Sprinkle some ceiling glitter onto the canvas and paint more of the melted wax on top to make it stick. Cover the whole canvas with the glitter and wax to finish the piece.

ACRYLIC GROUND MEDIUM

Acrylic ground medium is strong. There is nothing gentle about it. So lay it on thick and play with it!

THE WORD IN ART

I love to add words, text and numbers to my artwork. They ground the piece for me. Even when I feel like I've created a visually interesting piece of art, if it doesn't include a letter or number, I feel like it is missing something. All is well in my world with the combination of stringing along my words as I paint. If you place your words and letters off to the side of your piece, or layer gesso or fabric over them, the viewer's eye will move around the painting, taking it all in. The words or numbers provide a visual treat. Often I will start a painting with a quip or saying I heard somewhere. The words often come first, not always, but often. Single words work well, too, like a mantra of sorts. My words are often the same on many pieces: *laugh, dance your dance, believe.* These are all words I live by. It makes sense to me to incorporate them in my work. If you can add a sentence or two that ties into your piece, you have created your story visually and as a story teller. Often my verbiage is humorous, because I see the world through humor and the oddities of day-to-day living. I can do a painting of an old saddle shoe, but if I add the words "scruffy little shoe" to the piece, people connect to it on a different level, almost an aha moment. They get it. My story becomes a story they connect with as well. Never underestimate the power and joy that comes with humor!

If the artwork comes first instead of the words, you'll still have a finished piece in the end. It's just a different way of getting there. I will paint and paint and paint a piece. Then, days later, some words may come to me and bam! The piece is complete. I love both processes of adding words to my pieces. Stay true to yourself, what you believe and the stories of your life. Your words will come to you.

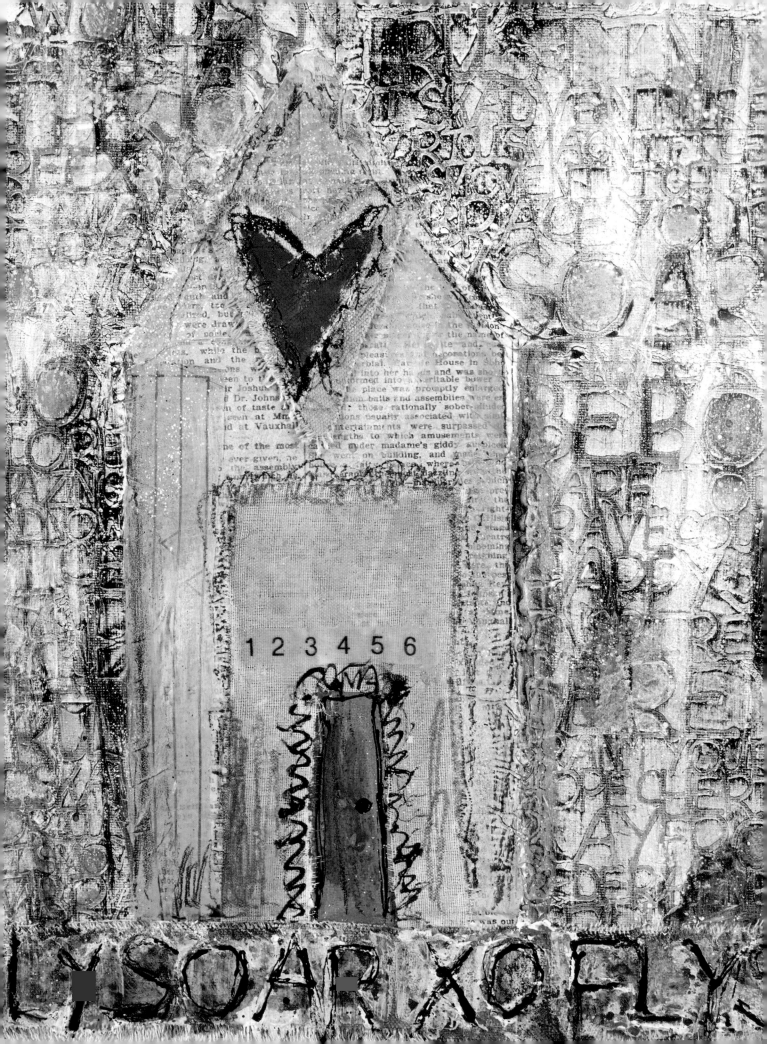

1 2 3 4 5 6

I SOAR & FLY

TUTU DRESS

Whenever possible, I love to incorporate fabric or unprimed canvas into a piece. It's all part of creating a mixed-media painting—layers and layers. When I saw cheesecloth at the fabric store I realized it was so thin that it would be an easy way to build up a textural surface on a painting. The tutu seemed to be a natural image to go with the wisp and whimsy of the cheese-cloth. When working with cheesecloth on canvas, throw perfection out the window; play, form and sculpt with your gel medium and pieces of fabric!

EVERY LITTLE GIRL ON THE PLANET DESERVES A TUTU SO SHE CAN TWIRL AND SPIN IN PURE BLISS AND WITH TOTAL ABANDONMENT.

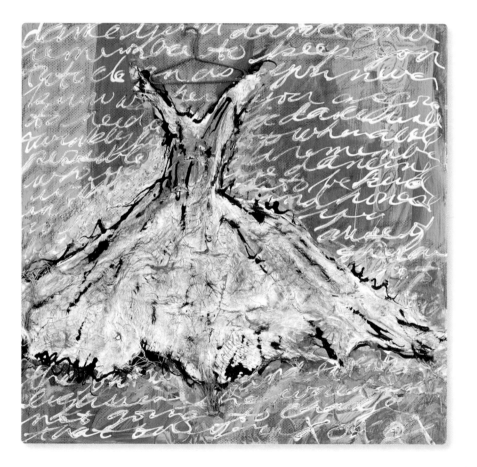

MATERIALS LIST

2" (5cm) chip brush

6B graphite crayon

12" × 12" (30cm × 30cm) stretched canvas

acrylic paints and brushes

black ink

colored inks

fabric stiffener

gray gesso

heavy matte gel medium

pencil

pipette

puffy white fabric paint

small wire hanger

white cheesecloth

white tissue paper

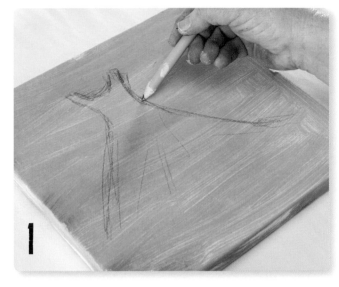

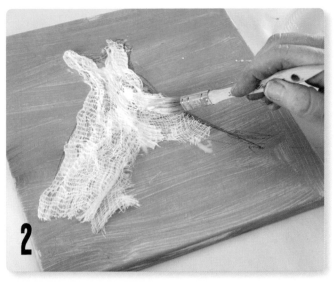

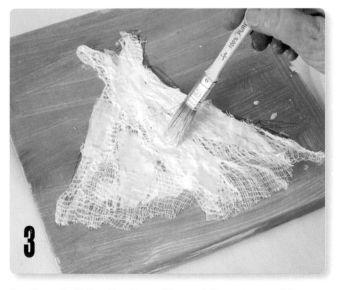

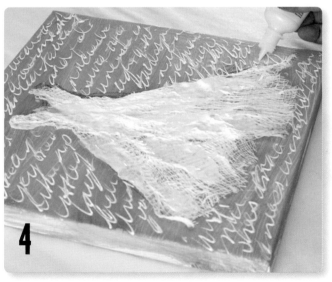

Paint the Background and Sketch the Dress Loosely apply acrylic paint to the canvas for the background. Keep your color palette simple. The dress and the words should be the focal point.

Let the paint dry, then sketch a quick outline of your dress shape onto the canvas with a pencil.

Add Cheesecloth Put fabric stiffener onto a plate or bowl. Cut strips of cheesecloth and tissue paper. Adhere a strip of the cheesecloth onto the canvas with the heavy matte gel medium. Then paint over it with the fabric stiffener. Continue layering strips of the cheesecloth to create the foundation of the dress shape.

Continue Building the Dress Shape Adhere layers of tissue paper on top of the cheesecloth with the heavy matte gel medium. Continue to add more strips on top of each other to create dimension. Then paint over the strips with the fabric stiffener so they hold their shape when they dry. Let the cheesecloth and tissue paper wrinkle to create folds and movement.

Add the Words Use puffy white fabric paint to write words across the background. Write whatever phrases and words come to mind. It's OK if the words aren't clear; the shape and expression are what's important. Let dry.

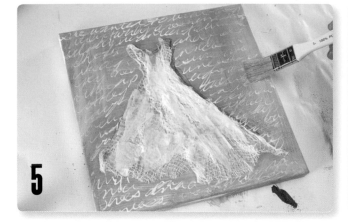

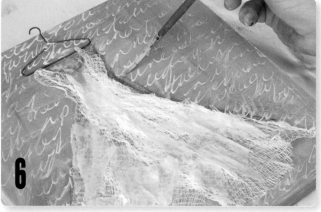

Add Acrylic Paint Once the fabric paint is dry, drybrush layers of color into the background with acrylic paint. Don't paint too heavily and cover up all the words. Just a touch of color is good.

Outline With Ink Attach a small wire hanger at the top of the dress with the gel medium. Outline the dress with a bright yellow ink to make it pop.

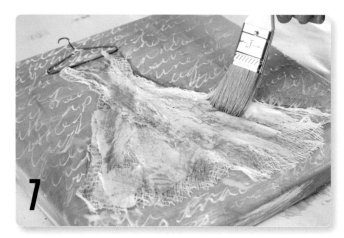

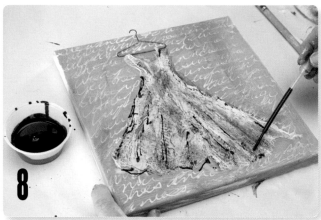

Add Gesso Lightly add gray gesso on top of the dress with a 2" (5cm) chip brush to bring out the texture and fibers of the cheesecloth and tissue paper.

Final Details Rub the 6B graphite crayon over the fabric of the dress to add more dimension and shading. You can also use the crayon over the background to add a bit of grittiness to the words.

Outline the dress with the pipette and black ink. Don't worry about drips and dribbles. There can be perfection in imperfection! Continue adding black ink to finish the piece.

CHOOSING MATERIALS

Any loose fabric will do to create your dress. The cheesecloth and tissue paper are light and airy, but don't be afraid to try other materials!

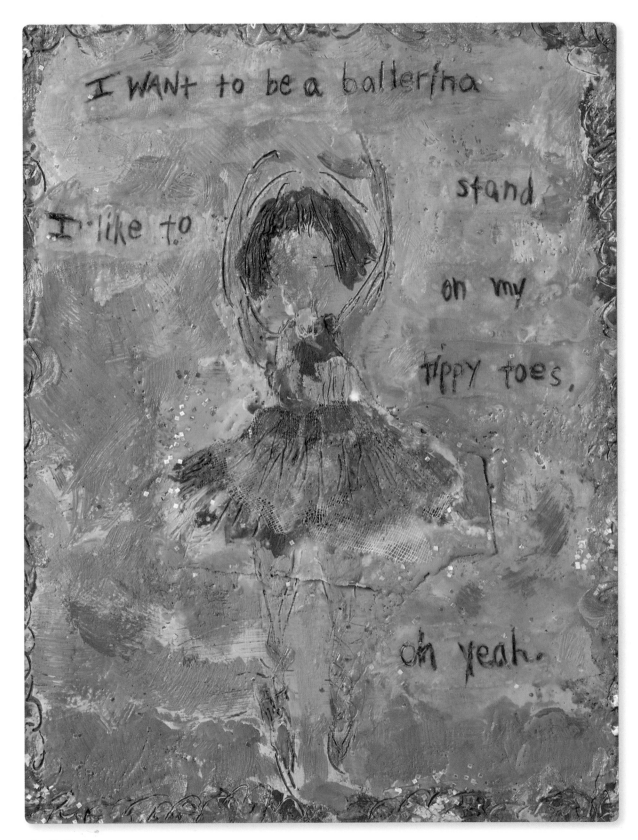

The Ballerina

For a different tutu piece, I used cheesecloth again in an encaustic painting I did of my daughter when she was a little girl. She would wear a tutu to daycare. When I created this piece, I just used a small scrap of cheesecloth to create the texture for the skirt, collaging it onto the painting with wax.

BURLAP BRAILLE

I have always been a big fan of burlap because you can fray it. It has a great textural quality to it, and burlap bags or sacks often come with graphic lettering that is perfect to use in a mixed-media painting. The burlap I used in this painting was from a coffee bag I found at a flea market that had the number 3 on it. It's a number that is repetitive in my work since my kids and I are a strong tribe of three. When drybrushing gesso on burlap you will pick up the weave of the burlap for an immediate textural layer to your piece. Try printed burlap for some instant graphics to incorporate into your work.

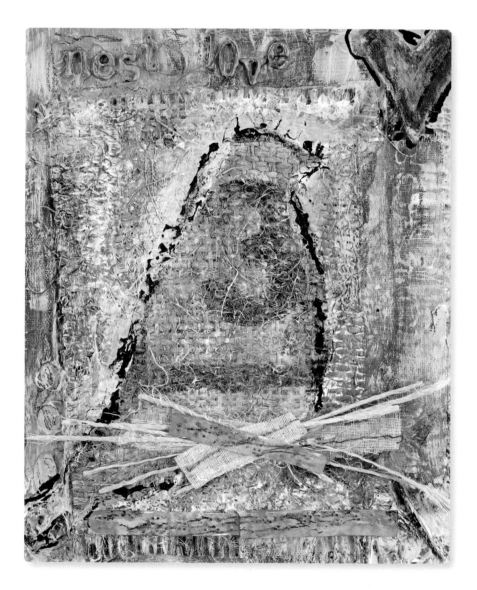

MATERIALS LIST

2" (5cm) chip brush

6B graphite crayon

9" × 12" (23cm × 30cm) stretched canvas

acrylic paints and brushes

bird stencil

black ink

crinoline

heavy matte gel medium

modeling paste and spreader

piece of printed burlap with words, numbers or images

pipette

scrim fabric

strips of printed braille

vintage letters or text

white gesso

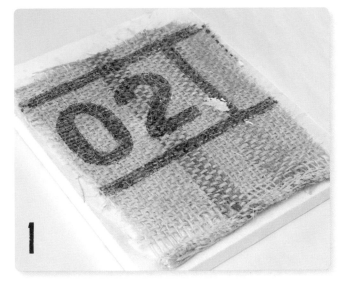

1

Attach the Burlap to Canvas Adhere your chosen piece of burlap to the canvas using the heavy matte gel medium. For more texture, a piece of scrim fabric can be added over the burlap.

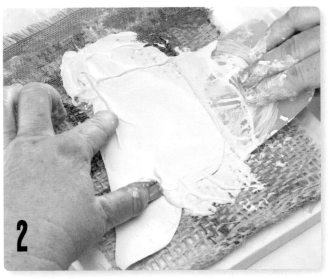

2

Stencil the Bird Place the bird shape onto the canvas. Placement is everything. If you want a number or letter to show, make sure your bird is on top of that area. Firmly hold the stencil in place. Spread modeling paste over the stencil to get good coverage. Let dry.

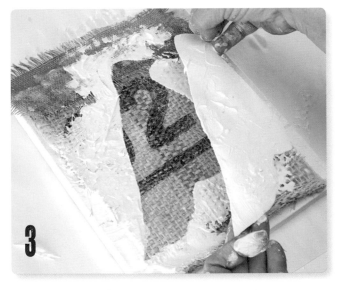

3

Remove the Stencil Once the modeling paste is dry, carefully lift up the stencil to reveal the bird shape.

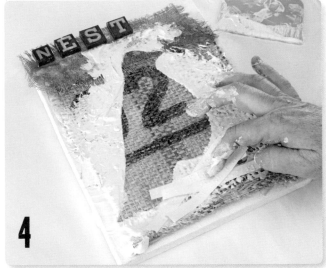

4

Add Braille Strips and Letters Create a nest beneath the bird. Cut strips of braille-imprinted paper, crinoline and fabric for texture. Add them to the bottom of the piece with gel medium. Continue layering multiple strips to create the nest. Then adhere your chosen letters to the top of the canvas using gel medium.

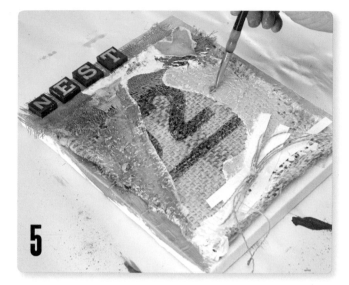

5

Add Color to the Background Use a limited color palette (four or five colors) to add color to the background with a 2" (5cm) chip brush. Do not paint inside the stenciled bird yet. Collage a canvas heart and burlap threads to the surface with gel medium for added detail.

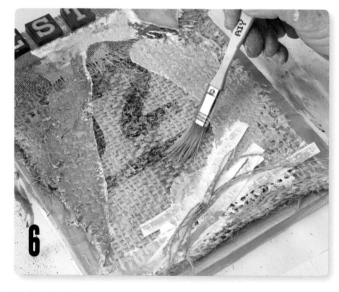

6

Paint the Bird To add color to the bird, water down your choice of acrylic paint so the burlap shows through under the paint. Let dry.

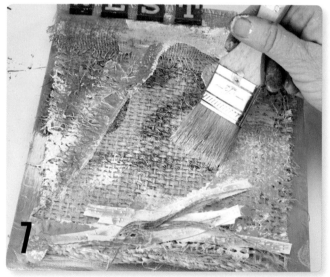

7

Add White Gesso Dip a dry 2" (5cm) chip brush into some white gesso, then blot off most of the paint with a paper towel. Lightly drybrush gesso over the piece, highlighting the texture of the fabric.

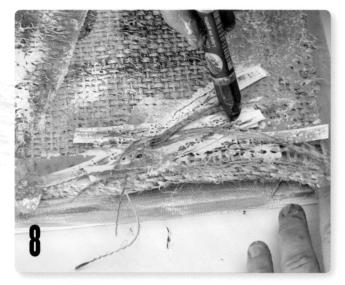

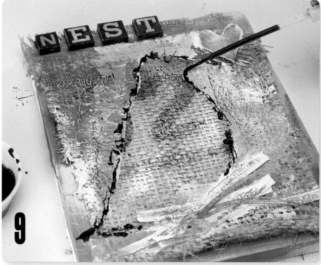

Bring Out the Texture Go back with a 6B graphite crayon to add more lines. Drawing over the braille strips brings out the texture of the braille. Stay loose and add lines anywhere you see fit.

Final Details To finish the piece, outline the shape of the stenciled bird with the pipette and black ink. Keep your lines loose as you work. You can also outline the bird with a bright-colored ink if you want the shape to stand out.

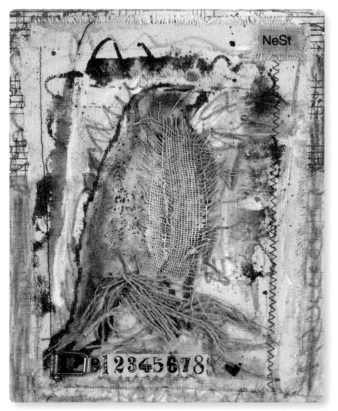

Nest

This piece incorporates a lot of layers. The stitched crinoline and frayed burlap pieces give a very textural look. The bird imagery is still the focus, but the layers are built up to create visual interest with fabric, paper, a vintage measuring tape, paint and ink.

THE STENCILED WORD

A common theme I have in my artwork is the use of letters, words and phrases. The text often comes to me as I am working. However, many times, a phrase or a snippet inspires me to create a painting. I find myself jotting down sayings or words that I may add to a piece at a later date.

I love this stencil from StencilGirl Products. For this piece I wanted it to be about not necessarily being able to read every word that was on the stencil but more about layering the words with modeling paste to build up a textural background. I love the fact that some words stand out and you have to search for others. The stenciled background works with the collaged printed text on the house. The fun of mixed media is to truly mix things up!

SHE THOUGHT OF HER HOME,
AND THE WORDS CAME FORTH.
SHE STENCILED THE WORDS
QUICKLY, LEST SHE FORGET.

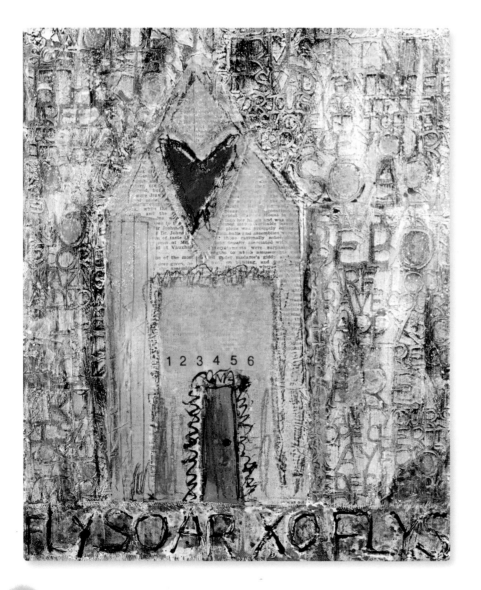

MATERIALS LIST

6B graphite crayon

12" × 12" (30cm × 30cm) stretched canvas

acrylic paints and brushes

art plaster

black gesso

crinoline

heavy matte gel medium

label maker

letter stencil (StencilGirl products)

modeling paste and spreader

pattern paper

piece of unprimed canvas

puffy black fabric paint

scissors

silver glitter mist

vintage paper

water-soluble oil pastels

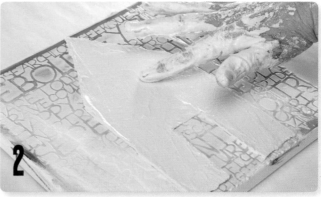

Stencil the Canvas Prep a canvas by painting a basic background with acrylic paint. Let dry. Place the word stencil you've decided to use over the painted canvas. I used a stencil from StencilGirl Products. Spread modeling paste over the entire surface, both the stencil and canvas. Make sure to cover the edges. Gently lift off the stencil to reveal the raised letters and words. Let dry.

Add the House Cut a house shape out of unprimed canvas. Dip the house into art plaster, covering it thoroughly. The art plaster will harden the canvas shape and adhere it to the main canvas. Place the plastered house onto the canvas, smoothing out the wrinkles.

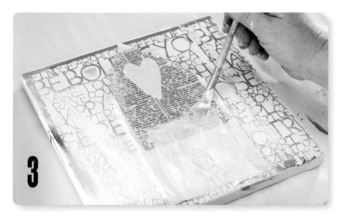

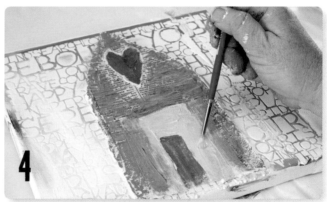

Collage Vintage Paper Time to personalize your house. Cut vintage paper to fit the house shape and collage it on top with the gel medium. Add a piece of crinoline at the base of the house and a canvas heart shape at the top.

Add Color Add the first layer of acrylic paint to the house. Use a few different colors to create a doorway and add visual interest.

ART PLASTER PRIMER

Art plaster will change your life. Unlike regular plaster, it is strong and stands up against chipping. You can do a lot with art plaster. For this house piece the use of art plaster is fairly subtle with a slightly raised house shape. This is what mixed media is all about: combining and exploring materials in new ways and new combinations.

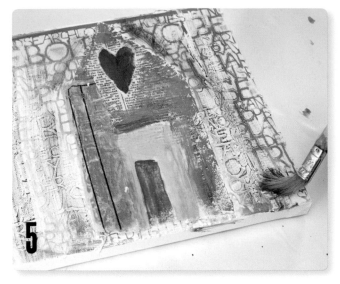

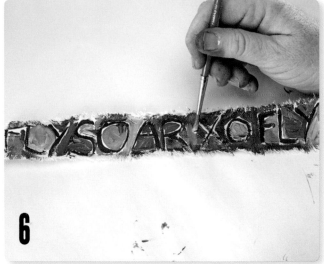

Continue Building the Layers Collage a strip of pattern paper onto the house shape using the gel medium. Lightly drybrush black gesso onto the background to bring out the stenciled letters. You can also use the water-soluble oil pastels to add more color to the background and the house.

Stencil and Paint a Canvas Strip Cut a strip of canvas and stencil letters over it with modeling paste. Let dry.

Once the paste is dry, use a small brush to bring out the stenciled letters with black paint. Let that dry, then paint the background color around the letters. It's OK if your painting is not perfect or if some of the canvas still shows.

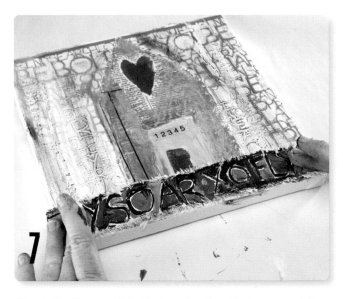

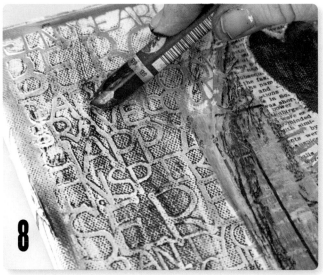

Attach the Canvas Strip Adhere the stenciled canvas strip to the bottom of the canvas with gel medium. Use a label maker to create a strip of numbers to adhere above the doorway of the house with gel medium.

Add More Texture Rub a 6B graphite crayon over the background and the house to make the stenciled words pop and to create more texture.

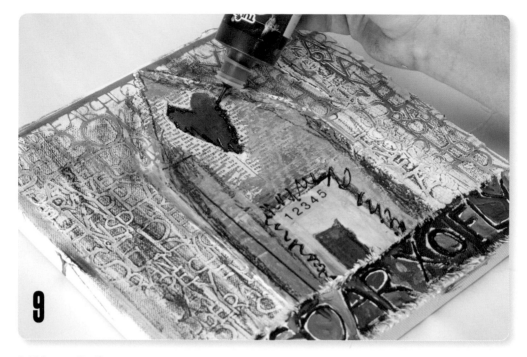

9

Add Loose Outlines Paint around the door of the house and the canvas heart with black fabric paint. Make sure to keep your lines loose.

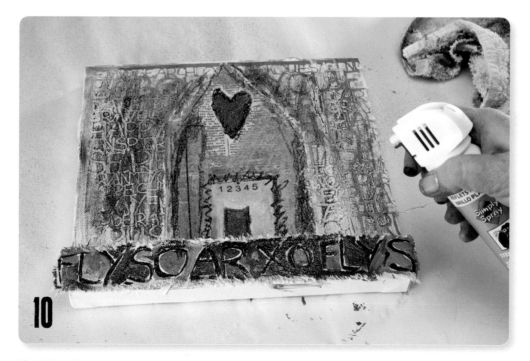

10

Final Detail Finish the painting by spraying silver glitter mist over the whole canvas.

WORDS IN MODELING PASTE

I love to use modeling paste in my paintings because it is so forgiving. It's great for mixed media. If you slather on modeling paste and are drawing or writing into your work, you can always go back and wipe it clean and start all over again (just use an old credit card). Modeling paste has some chutzpah to it. You can go into a piece and rework it, write in it and scribble into it. It also gives a sense of immediate surface buildup when dry. The dry peaks of the modeling paste give you an instant texture to begin with when you're ready to add paint. Modeling paste on unprimed canvas is a great way to begin a painting. It's like a contour drawing but with dimension.

YOU CAN WRITE A STORY AND READ IT. OR YOU CAN CARVE IT INTO MODELING PASTE AND REMEMBER IT FOREVER.

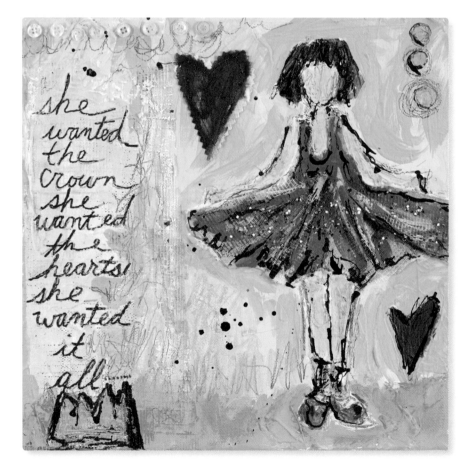

MATERIALS LIST

12" × 12" (30cm × 30cm) stretched canvas

acrylic paints and brushes

black fabric paint

chunky glitter

heavy matte gel medium

modeling paste and spreader

pencil

scissors

scraps of crinoline and canvas

vintage buttons

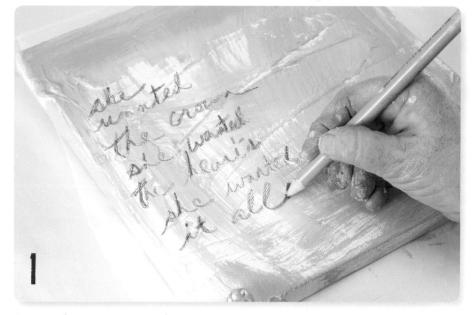

Add the First Layer of Modeling Paste Slather modeling paste over the entire canvas. Use the same technique you would for frosting a cake. Let the modeling paste dry completely. Then add color with an acrylic wash. While the paint is still wet, write your sentiment in pencil. Try to limit the writing to the left side of the canvas.

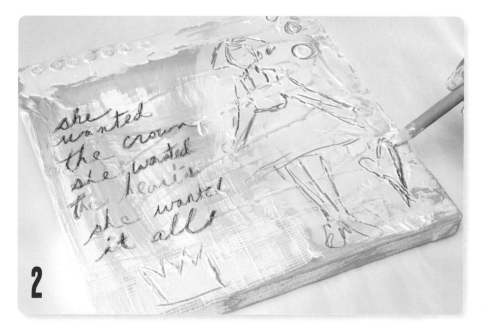

Add More Modeling Paste Add more modeling paste to the right side of the canvas. While the modeling paste is still wet, use a pencil to draw into it. Press down hard to make an impression in the paste. Add a bit of modeling paste above and below your text. Press a row of buttons into the wet paste at the top of the canvas and draw into the paste at the bottom of the canvas. Let dry.

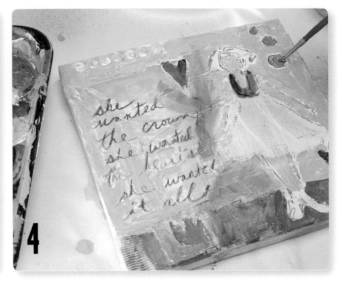

3 Create the Girl's Dress Cut a small heart out of canvas and adhere it near the girl (I've adhered it in the center of the canvas, near her head). Then cut and adhere unprimed canvas with the heavy matte gel medium to create the shape of the girl's dress. Give the dress dimension and folds by adding a piece of crinoline on top. Cover the whole strip of crinoline with gel medium so you can shape and fold it on the canvas. Let dry.

4 Paint Over the Modeling Paste Go back with the yellow acrylic paint to cover up any modeling paste that isn't painted. Add more colors to the background and paint the hearts, circles, crown and figure.

BUTTON DETAIL

I love to use vintage buttons in my work, usually a row on the top or bottom of a piece. It adds a nice dimension and the round button shape fits with the drawn and painted circles I often add to my paintings.

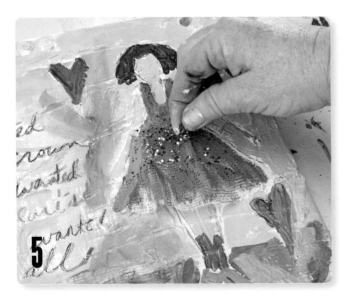

5 Add Glitter Paint the dress and the girl's shoes with acrylic paint. While the paint is still wet, sprinkle some glitter on top. Let dry.

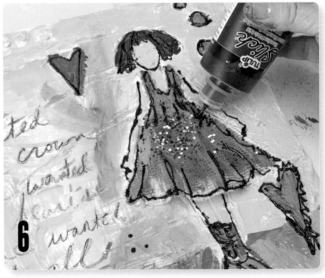

6 Final Details Once the paint is dry, outline the figure and background shapes with the black fabric paint to finish the piece.

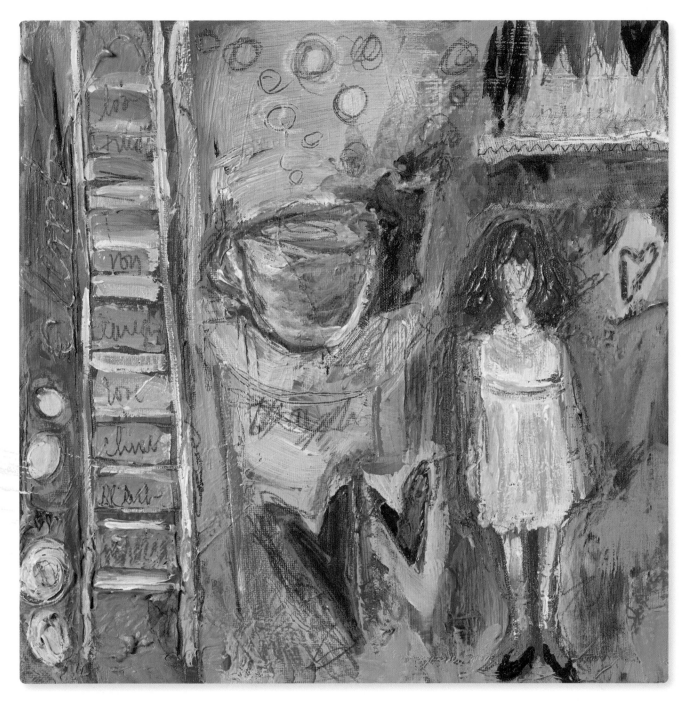

The Coffee Cup and Ladder

This piece was created using a layer of modeling paste spread over a 12" × 12" (30cm × 30cm) canvas. The little snippets of drawings were drawn into the modeling paste while it was wet, basically creating a contour drawing/outline to begin layering paint. The imagery here is what is always near and dear to me: my daughter, coffee and a ladder for growing and climbing on the journey. Allow the paste to dry and then begin building up your piece with paints and color.

THE PARIS CRAFT HEART

The Paris Craft allows you to build up the shape or image you want to work with onto the canvas in a two-dimensional way. Any shape may be formed with the Paris Craft. Allow it to dry and then you can add paint. You may also use the Paris Craft to layer your canvas, creating the texture you want to paint with as your immediate background. The beautiful thing about Paris Craft is that it dries quickly. There's no need to sit around and wait for paint or mediums to dry.

THE WORDS BELONGED SAFE AND SOUND IN HER HEART.

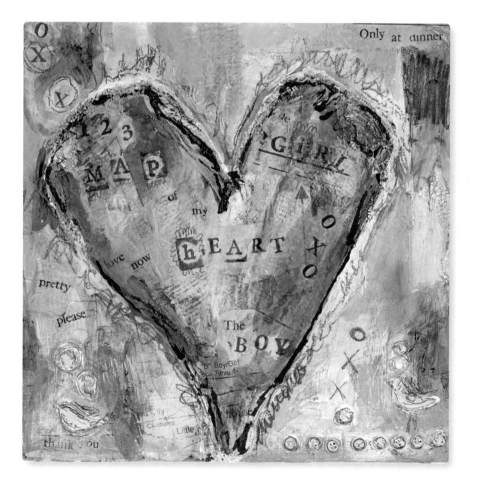

MATERIALS LIST

6B graphite crayon

12" × 12" (30cm × 30cm) stretched canvas

acrylic paints and brushes

black ink pad

handmade bird stencil

heavy matte gel medium

letter stamps

modeling paste

Paris Craft

red ink

tissue paper

vintage buttons

vintage pattern paper

water-soluble oil pastels

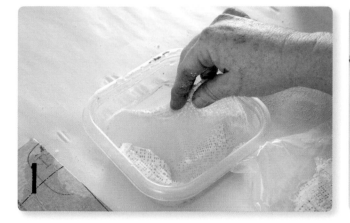

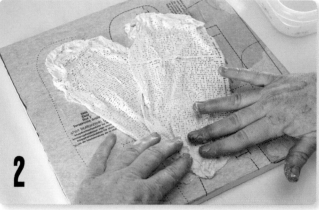

Activate the Plaster Prepare the background of your canvas by adhering strips of vintage pattern paper to it with gel medium. Cut strips of Paris Craft. Then place them into warm water to activate the plaster.

Add Paris Craft to the Canvas Place the wet strips of Paris Craft onto the prepared canvas and arrange the strips into a heart shape. Let dry.

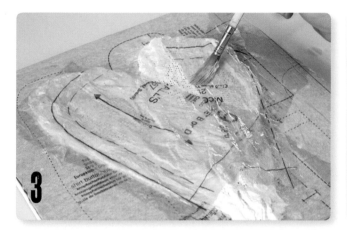

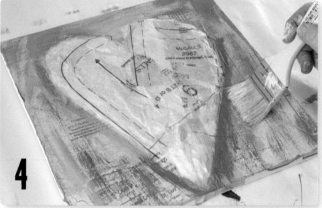

Collage Paper Once the Paris Craft is dry, collage vintage pattern paper on top of the heart shape using watered down gel medium. Numbers, words, arrows, lines and other graphics can all be found on pattern paper. Consider which graphics you want to use and in which direction you want them to go. Cover the paper well with gel medium. Let dry.

Start Adding Color Drybrush acrylic paint onto the background, making sure you can still see some of the pattern paper. You want to retain the symbols and words on the paper.

PATTERNS AND PARIS CRAFT

I am obsessed with anything vintage I can use in my work. Can't find vintage patterns? Buy a couple of new patterns. They'll give a similar look.

Use warm water when using Paris Craft. It dries faster and holds together better. There is something oddly therapeutic about dipping your hands into plaster. Once you start using plaster, you may not be able to stop.

Drips from the Paris Craft left on your canvas can either be scraped away or used to create more texture to play with.

VISIT **CREATEMIXEDMEDIA.COM/COLLAGEPAINTDRAW** FOR BONUS DEMONSTRATIONS!

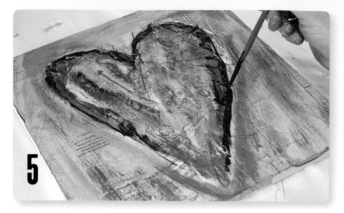

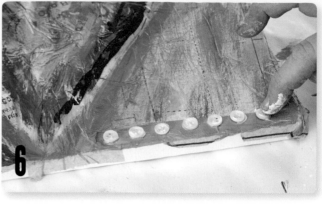

Paint the Heart Paint a layer of color onto the heart with acrylic paint. Then outline the edge of the heart with a small brush and red ink.

Add Button Detail Continue layering colors and texture onto the background with acrylic paint and the water-soluble oil pastels. Use gel medium to adhere buttons to the edge of the canvas for added dimension.

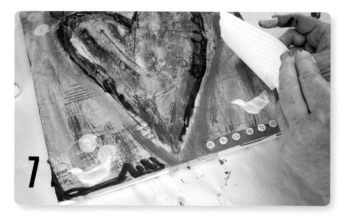

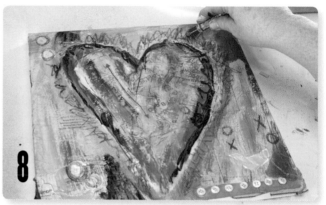

Stencil Birds Stencil a couple of small birds onto the canvas with modeling paste. You can use an index card to create a simple stencil. Let the modeling paste dry.

Add Loose Lines Once the birds are dry, paint them with acrylic. Outline the heart, the birds and your other background shapes with a 6B graphite crayon. Have fun and scribble the lines. Keep your lines loose and gestural.

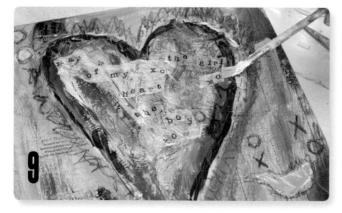

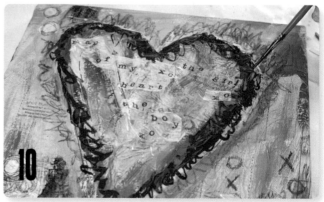

Collage the Tissue Paper Using the letter stamps and a black ink pad, stamp your chosen words onto tissue paper. My chosen words represent the map of my heart: the girl, the boy, a house. These are all words and imagery repeated in my art. What has meaning to you? Trim the tissue paper to fit into the heart. Carefully adhere the tissue paper to the canvas with watered down gel medium. Let dry.

Final Details Finish the piece by painting final details and adding any last layers of color. Then outline the heart again with red ink and a small paintbrush.

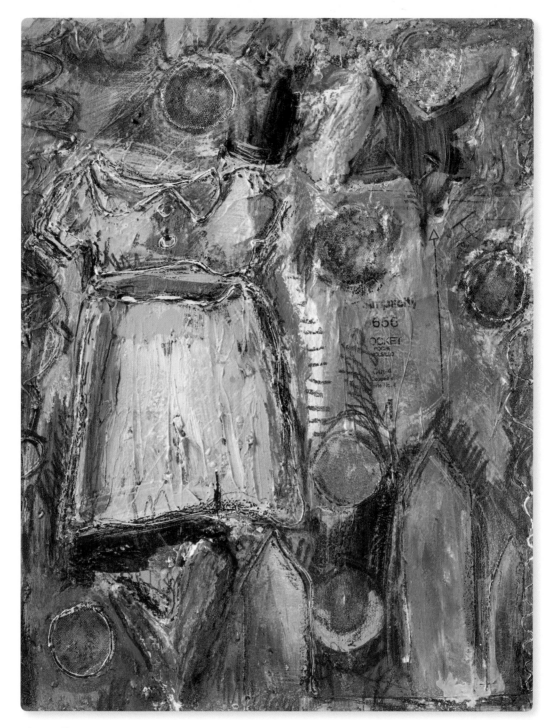

The Yellow Dress

Whereas the Paris Craft heart is a defined image with the Paris Craft, it is an excellent material to add wet to a canvas before you start painting to build up a textural surface. For this piece, I laid several strips of the wet plaster on the canvas in a random way, building up some areas with several layers of the Paris Craft. When it was dry, I began painting, allowing the images to come to me as I worked. I didn't know where the material would lead me. Often the best way to start a painting is to just start and see what direction you will head. Putting the Paris Craft on the canvas before you paint takes the fear of the blank empty canvas out of your painting experience.

DANCING AROUND YOUR CANVAS WITH PAINT AND LAYERS

Painting in my mixed-media world means so much more than paint application. It means layering the paints with mediums, glazes, fabrics, inks and pastels. I am always trying to come up with new ways to combine materials. My rule of thumb is if it is all water-based then you should be good to mix and layer. A sense of play and exploration is a big part of what I believe you need to have in your paintings. Very rarely do I use a brush smaller than a ½" (1cm) chip brush. I like to work bold and loose, and often a small brush feels confining. I love adding those bold strokes over collaged pieces on the canvas. I usually jump right in and begin adding a layer of something so I'm not looking at a blank canvas. Suddenly there's no angst since there is already something on the canvas. It is freeing.

When I paint I like to think I am dancing around my canvas with my paint. However, even if you are dripping, globbing and smearing paint, you want your finished piece to have a cohesive feel to it. Make sure you are looking at the entire canvas as you work. The viewer's eye should always move around the canvas. If you use a bit of periwinkle in an area, make sure there is periwinkle elsewhere on the painting. I am typically drawn to the same color palette—periwinkles, purples, pinks, yellow-green. These colors make sense to me, and they go hand in hand with the imagery in my work.

Play with your paint, explore, overlap, mix, blend and scratch through your paint. Just keep a looseness and freshness about it!

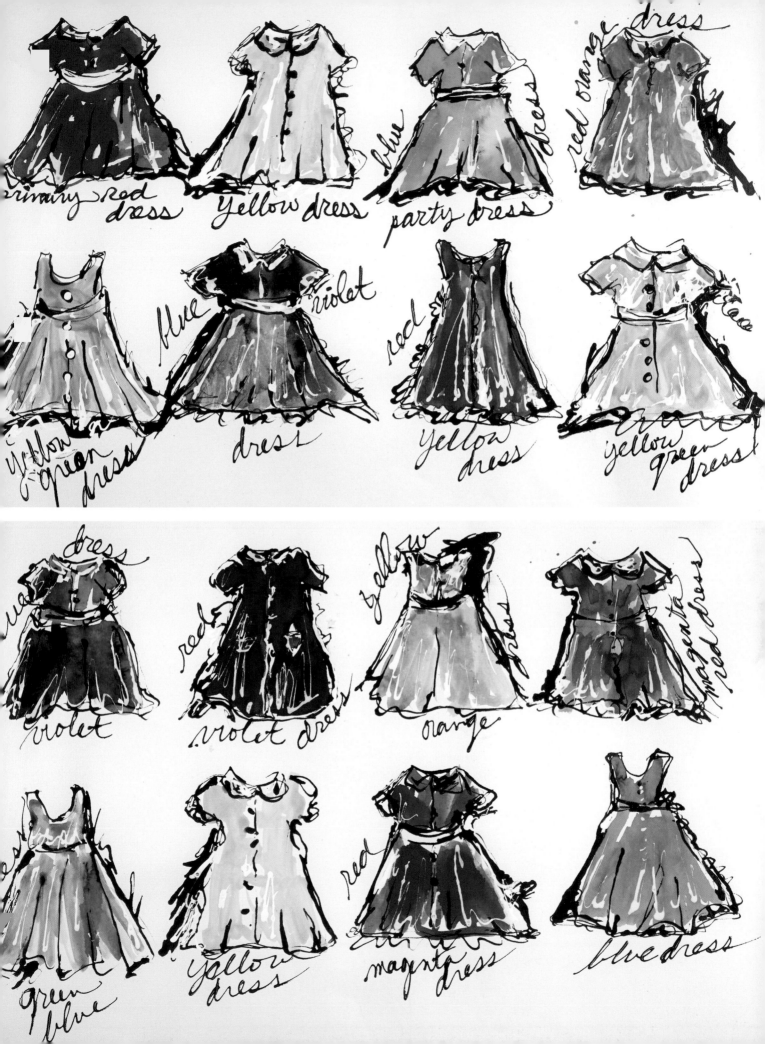

primary red dress

Yellow dress

blue party dress

red orange dress

yellow green dress

blue violet dress

red yellow dress

yellow green dress

violet

red violet dress

yellow orange

magenta red dress

green blue

yellow dress

red magenta dress

blue dress

PAINTING WITH A PIPETTE

I have been painting for years and I love my paintbrushes, but a pipette is a liberating art tool. Plus, it's inexpensive! It goes back to having control over your mark making but allowing for the unexpected. I love to go back into a piece and outline it with a pipette and colored ink, thick lines, thin lines, squiggly lines, particularly in a mixed-media piece where you may have layers of fabric on your canvas. I suggest taking a piece of paper and practicing. Experiment with various lines, dragging the pipette across the canvas and figuring out how much pressure you should use for the ink flow, but don't overthink it! Practice for five minutes tops, then just go for it!

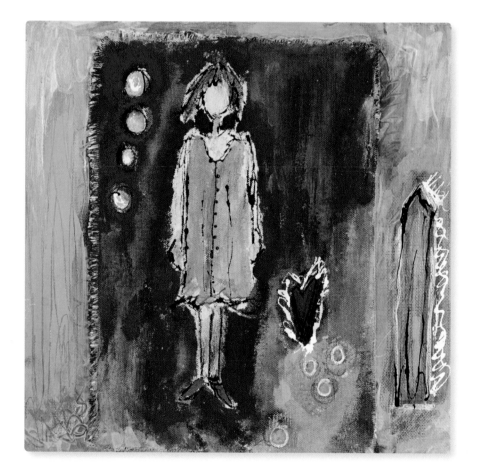

MATERIALS LIST

9" × 12" (23cm × 30cm) canvas

acrylic paints and brushes

black ink

heavy matte gel medium

pencil

piece of unprimed canvas

pipette

water-soluble oil pastels

white fabric paint

Prepare the Background Paint a colored background onto the canvas with acrylic paint. Cut a strip of unprimed canvas. Water down some acrylic and paint the unprimed canvas with a wash. Attach the painted strip to the main canvas with gel medium. Let dry.

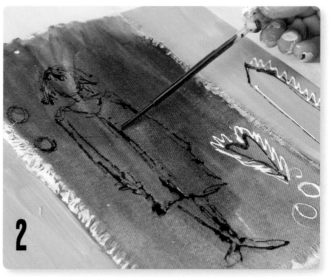

Sketch the Figure Fill the pipette with black ink and loosely sketch a figure. You can draw the figure with pencil first if doing so will make you more comfortable. Practice the amount of pressure to use with the pipette on a separate piece of paper before starting the figure. Add circles, a heart and a house shape to help define the background. Go around the heart and house with white fabric paint. Let dry.

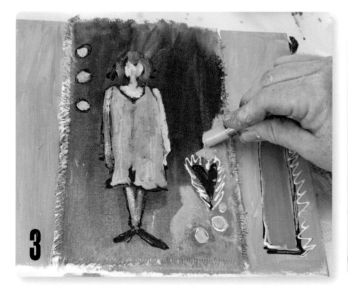

Add Color Fill in the figure and shapes with acrylic paint without covering the ink lines too much. Add more color and dimension to the piece with additional layers of acrylic paint and water-soluble oil pastels.

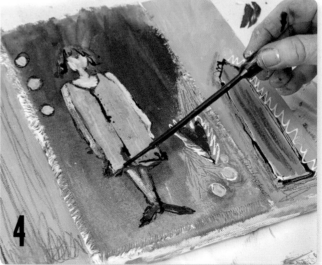

Final Details and Texture Go back into sections of the background with a pencil and add lines for more texture. Finish the piece by outlining the figure one last time with the pipette and black ink.

PAINTING WITH WATER-SOLUBLE OIL PAINTS

A few years ago I discovered water-soluble oil paints, which have all the lushness of oil paints but not the odor. Although they certainly take longer than acrylic paints to dry, they're fun to work with. I started by picking up a starter pack at a nearby art store. They are amazing to mix on your canvas while you are working, scratching into paint for texture and reworking a piece until you are happy. Try them!

SHE USED OIL PAINTS A LIFETIME AGO. THEY TOOK FOREVER TO DRY, AND PATIENCE WAS NEVER ONE OF HER VIRTUES. THEN SHE DISCOVERED WATER-SOLUBLE OIL PAINT, AND SHE NEVER LOOKED BACK.

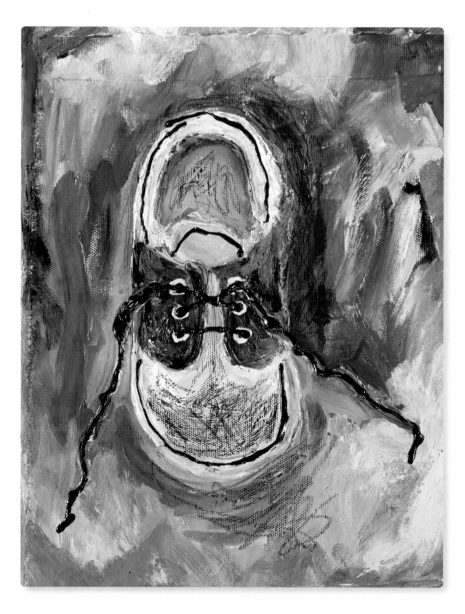

MATERIALS LIST

6B graphite crayon

12" × 12" (30cm × 30cm) stretched canvas

brown and white fabric paint

crinoline

heavy matte gel medium

hot-pressed watercolor paper

modeling paste

paintbrushes

pencil

plastic icing dispenser

water-soluble oil paints in colors of your choice (be sure to include white for mixing)

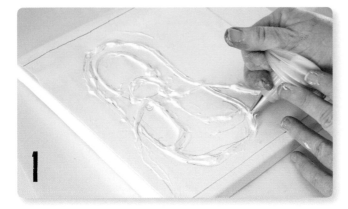

1

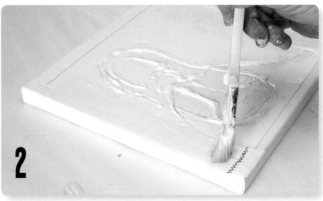

2

Create the Shoe Shape Lightly sketch the shape of a shoe onto hot-pressed watercolor paper. Adhere the paper to the canvas with gel medium. Fill a plastic icing dispenser with modeling paste and outline the pencil lines with a thick layer of paste. This will give your piece dimension.

Add Texture Add texture around the edges of the canvas by adhering strips of crinoline with gel medium.

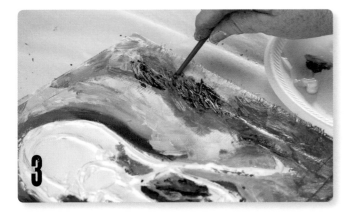

3

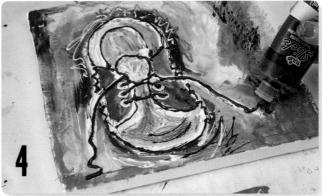

4

Add Color Paint the shoe and the background with the water-soluble oil paints. These paints provide a rich look so explore that while you paint. You can mix and blend colors directly on the canvas or mix them on a separate palette. Try to keep the color palette to a minimum, creating new colors on the canvas as you blend. Add texture to the background by scratching the still-wet paint with the end of your paintbrush.

Final Details Add more color to the shoe, using the modeling paste lines as a guide. Make marks with a 6B graphite crayon while the paint is still wet. Let dry.

Apply white and brown fabric paint over the raised lines you created with the modeling paste. Doing so brings your shoe to life!

WATER-SOLUBLE OIL PAINTS

These paints take longer to dry than acrylics but a lot less time to dry than traditional oils. Because your piece will remain damp, you will have a few days to go back and continue to work on it.
I have a small set of these paints. If you have the primary colors and a large tube of white, the possibilities are endless. You never need to break the bank when purchasing paints.

MARY JANE WITH GLITTER GLAZE

When I was little I wore Mary Janes, usually scruffy and worn in, but I remember thinking they were the ultimate in shoe attire. When my daughter was small I bought her a pair too. In life it's important to remember that some things never change; some things are classic. I believe Mary Janes are a classic. Adding them to my art and making them sparkle is something I love to do. With the glitter glaze you can always add more sparkle! You can mix the glaze into the paint while it's wet or layer it on top when your project is complete.

SHE ONLY WORE THE SCRUFFY MARY JANES WHEN SHE WAS OUT SAVING THE WORLD. THEY PUT A KICK IN HER STEP.

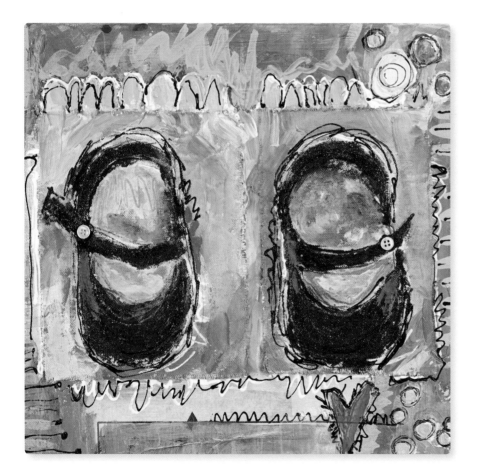

MATERIALS LIST

12" × 12" (30cm × 30cm) stretched canvas

acrylic paints and brushes

black and white fabric paint

glitter glaze

heavy matte gel medium

pattern paper

pencil

pieces of unprimed canvas

tacky glue

vintage buttons

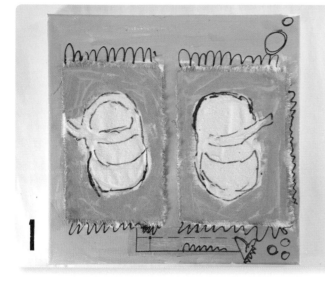

Create the Background and Sketch the Shoes Paint the background color onto your canvas with acrylic paint. Draw the shoes onto pieces of unprimed canvas using tacky glue so you get a nice raised line. Let the glue dry, then attach the shoes to your prepared canvas with gel medium. Outline the shoes with a pencil.

Paint around the shoes on the canvas strips with a contrasting color. Collage a strip of pattern paper along the bottom of the canvas with gel medium. Add detail and shapes to the background canvas with black fabric paint.

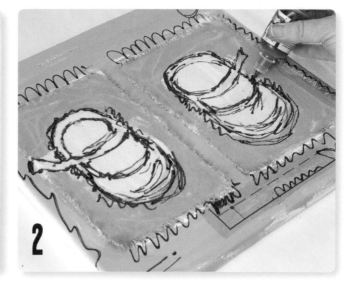

Define the Shoes Using the black fabric paint, go over the outlines of the shoe drawings to better define them and add texture. Keep your lines loose and fun. You can keep layering until you're happy. That's one of the beautiful things about mixed media. Let dry.

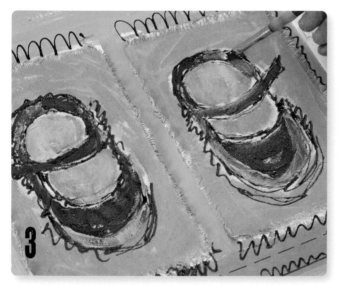

Add Color to the Shoes Once the fabric paint is dry, add the first layer of color to the shoes with acrylic paint. Continue building up the layers of color on the background and the shoes.

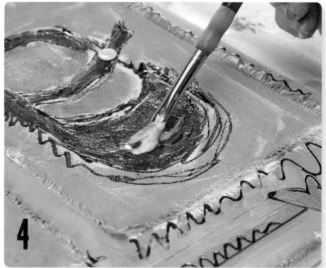

Final Details If desired, paint another layer of color on the shoes. Then add the glitter glaze. You can add as much or as little as you want. You can mix the glitter glaze into the paint while it's wet or wait until it's dry and layer it on top. Adhere a button onto each Mary Jane shoe. Finish the piece by adding more loose lines and shapes with black and white fabric paints.

CHALKBOARD PAINT TREE

I discovered chalkboard paint at the local craft store. I bought it and thought, why not apply the paint to a canvas and use chalk markers to draw on it? I thought about the green chalkboards hanging in my elementary school, and I felt inspired by that. Chalkboard paint comes in a variety of colors now. It is certainly a very forgiving medium; you can just wipe away what you don't like. Chalkboard paint isn't just for school anymore!

THE BLACK PAINT SORT OF SCARED HER, BUT WHEN SHE REALIZED SHE COULD USE CHALK ON IT AND WRITE AND DOODLE ON HER PAINTINGS, SHE WAS BROUGHT BACK TO SECOND GRADE.

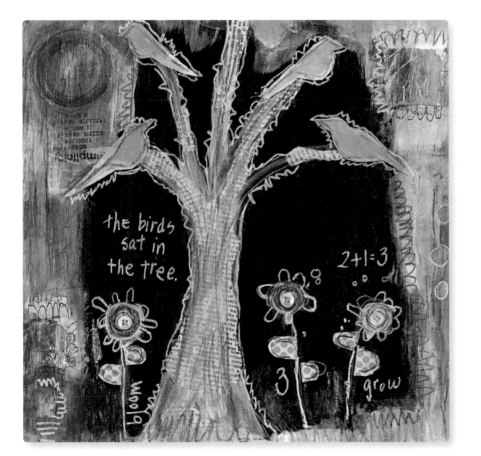

MATERIALS LIST

1" (2.5cm) chip brush

6B graphite crayon

12" × 12" (30cm × 30cm) stretched canvas

acrylic paints and brushes

black chalkboard paint

chalk marker

crinoline

fabric spray paint

gold leaf paper

heavy matte gel medium

scissors

vintage buttons

vintage paper

water-soluble oil pastels

white gesso

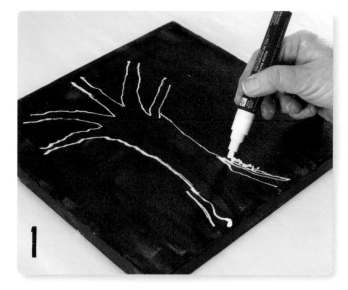

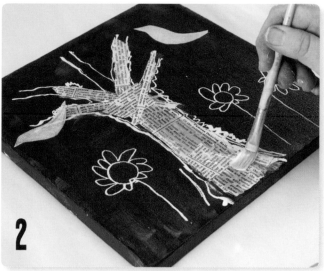

Paint the Background and Sketch the Tree Using a 1" (2.5cm) chip brush, cover your canvas with chalkboard paint. The black provides a nice contrast, but you can use any color chalkboard paint. Let it dry. Use a chalk marker to sketch out the tree and flower shapes.

Collage Vintage Paper Tear strips of vintage paper to collage into the tree. Apply them to the canvas with gel medium. This helps to build up the shape and texture of the tree.

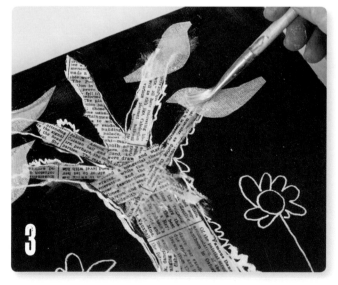

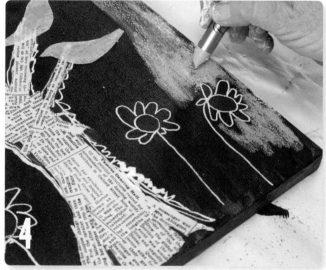

Add Birds Cut birds out of crinoline and collage them onto the tree branches with gel medium. Continue to collage and build up the layers until you're satisfied with how it looks.

Start Adding Color Use the water-soluble oil pastels to start adding color to the birds, flowers and the background.

VISIT CREATEMIXEDMEDIA.COM/COLLAGEPAINTDRAW FOR BONUS DEMONSTRATIONS!

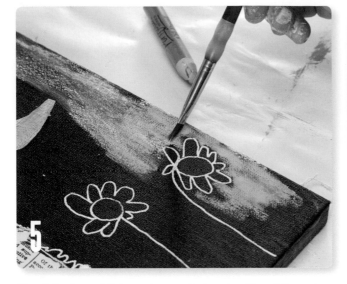

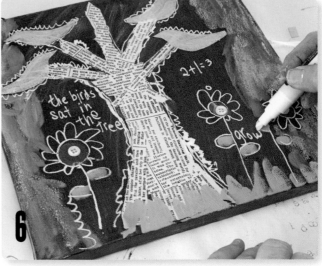

Blend the Pastel Take a clean paintbrush with a little water and blend the pastel onto the canvas. Continue to add color and build up the layers.

Write With the Chalk Marker Use the chalk marker to write words and numbers onto the background. Then outline the birds and flowers. You can also add fun details like the buttons in the center of the flowers.

CHALKBOARD PAINT

Chalkboard paint and chalk markers come in a huge variety of colors these days. Play with them! If you use regular chalk on the paint, be sure to seal the chalk drawings with a fixative.

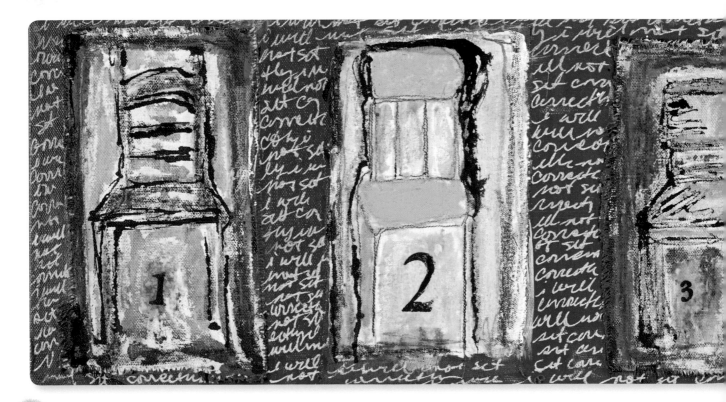

Add Gold Leaf Details Drybrush white gesso across a few sections of the canvas. Continue to develop the layers with acrylic paint and the 6B graphite crayon.

Adding a little gold leaf is a nice touch. Cut the desired shape from the full sheet of gold leaf. Paint gel medium onto the canvas where you want to place the gold leaf. Carefully press it down onto the canvas.

Final Details To finish the piece, spray the whole canvas with fabric spray paint. A metallic or glitter paint gives the piece sparkle. Let it dry.

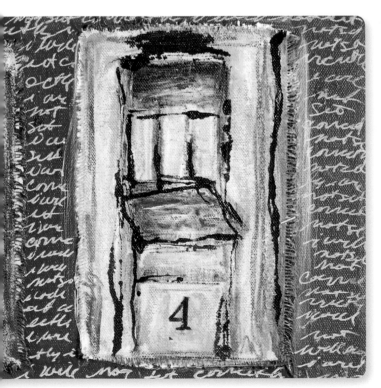

4 Little Chairs In a Row, They Weren't Just For Goldilocks and the 3 Bears Anymore

When I saw the green chalkboard paint, the school connection was instant for me. There weren't any whiteboards when I was a kid, just green or black chalkboards. Teaching elementary school art I often find myself sitting at meetings in tiny, made for kindergartner chairs, thus the inspiration for this piece. Everyone has an image from back in the day of someone writing their misbehavior over and over again. The green chalkboard paint background of this piece was a perfect match for that repetitive writing. My writing reads, "I will not sit in the chair correctly" because, in the scheme of life, sitting with perfect posture is overrated in my book!

STENCILED SHOES

The Mary Jane shoes are such a personal image for me, but whenever I showed the paintings with the shoes to people, they responded in a positive way. It seems everyone had a story about wearing the shoes, remembering specific occasions where they wore Mary Janes. So I decided to create a stencil of the shoes with StencilGirl Products.

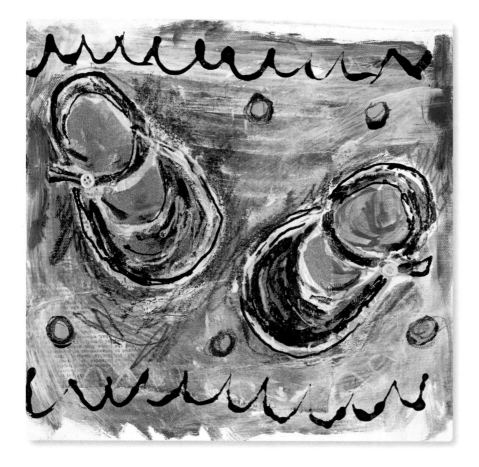

MATERIALS LIST

acrylic paints and brushes

black and white fabric paints

cosmetic sponge

crinoline

heavy matte gel medium

primed canvas piece

shoe stencil

vintage buttons

vintage paper

white gesso

1

Collage the Background Prepare the background of this piece by collaging strips of paper and crinoline with gel medium to a primed piece of canvas.

2

Stencil the Shoe Lay out the shoe stencil and dab black acrylic paint over it with a cosmetic sponge. Don't use too much paint or it will bleed together and you'll lose the lines of the shoe. Let the paint dry.

3

Carefully Remove the Stencil Stencil another shoe onto the canvas in the same way. Gently lift up the stencil to reveal the shoe. Let the paint dry.

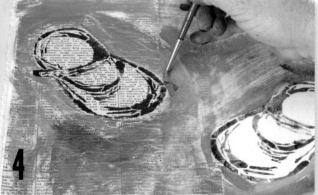

4

Add Background Color Start adding color to the background with acrylic paint. It's OK to blend the colors right on the canvas. Be sure some of the collaged paper shows through the paint. You don't want to cover it completely.

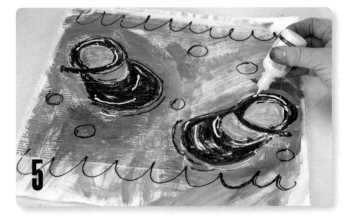

5

Fill In the Shoes Use acrylic paint and a small brush to fill in the shoe outlines created by the stencil. Add circles and waves in the background with black fabric paint. Outline the shoes with the black fabric paint as well, then go back to add details on the shoes with white fabric paint. Let dry.

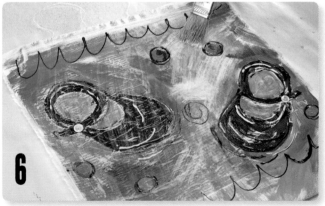

6

Final Details Add a little contrasting color to the center of the circles with acrylic paint. Attach buttons to the shoes with gel medium. Drybrush white gesso over the entire painting to finish the piece.

LIQUID WATERCOLOR

I have taught elementary school art for 25 years. I discovered liquid watercolors through a catalog I use when purchasing supplies for my art room. I love to use them with the kids because they are so easy. Just dip the brush into the color and paint. With the kids I pour the liquid watercolor into muffin tins. If they dry out from day to day I just add a bit of water to them and the color comes back. I began using them in my own work because the vibrancy is gorgeous. I appreciate a paint that is rich in color and can be easily mixed on paper as you are working.

IF YOU WORK QUICKLY, OFTEN MAGIC HAPPENS. IF YOU WORK SLOWLY, A DIFFERENT MAGIC CAN HAPPEN THEN, TOO.

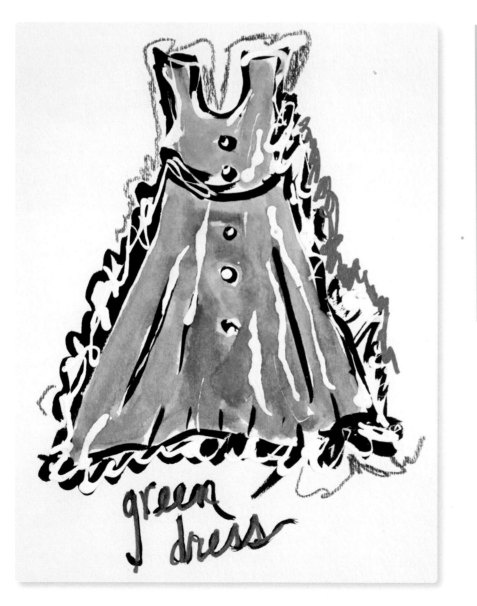

MATERIALS LIST

6B graphite crayon

140-lb. (300gsm) hot-pressed watercolor paper

black ink

liquid watercolors and brushes

metallic silver and gold permanent markers

pipette

white ink

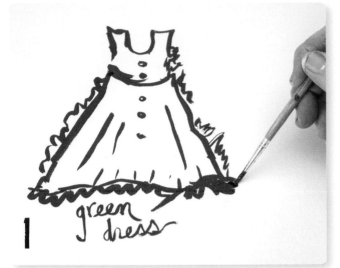

1

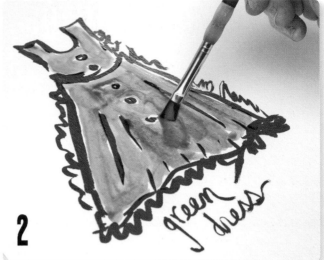

2

Sketch the Dress Sketch out a dress with a small paint-brush and black ink. Keep your lines loose as you paint. Let dry.

Add Color Add color inside the ink lines with the liquid watercolors. You can blend the color on the watercolor paper while it's still wet.

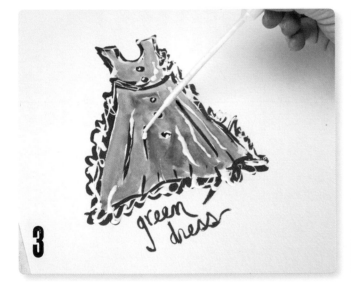

3

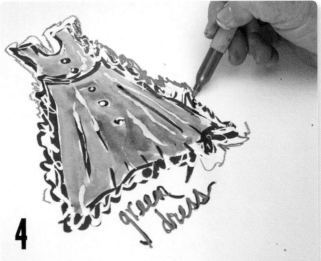

4

Add More Ink Lines Once the watercolor has dried, go back with a pipette and white ink to add highlights and dimension. Let dry.

Final Details When the ink is dry, add more lines around the dress with a metallic permanent marker and a 6B graphite crayon.

A LITTLE EXTRA SHINE

If you want to create more shimmer on your dress, paint over it with acrylic glitter glaze as a final step. Don't be afraid to experiment with your art!

VISIT CREATEMIXEDMEDIA.COM/COLLAGEPAINTDRAW FOR BONUS DEMONSTRATIONS!

SURFACE BUILDUP: WHY STAY TWO-DIMENSIONAL IF YOU DON'T HAVE TO?

If I was left on a deserted island with only three things, number one would have to be heavy matte gel medium. Number two would be modeling paste, and number three would be a freezer of ice cream.

When it comes to surface buildup in a mixed-media piece of art, the sky is really the limit. Mediums modify the consistency of paints, allowing you to use the paints in new energetic, explorative ways. I love to work with mediums, either mixing them into my paints or using them as binders or as adhesives. The versatility of most of these materials is great. As long as they are all water based, you can combine many mediums in one piece. I love having my work come off a canvas, and by that I mean, the fabric literally hangs off the edges or I have used materials to layer and create 3-D forms.

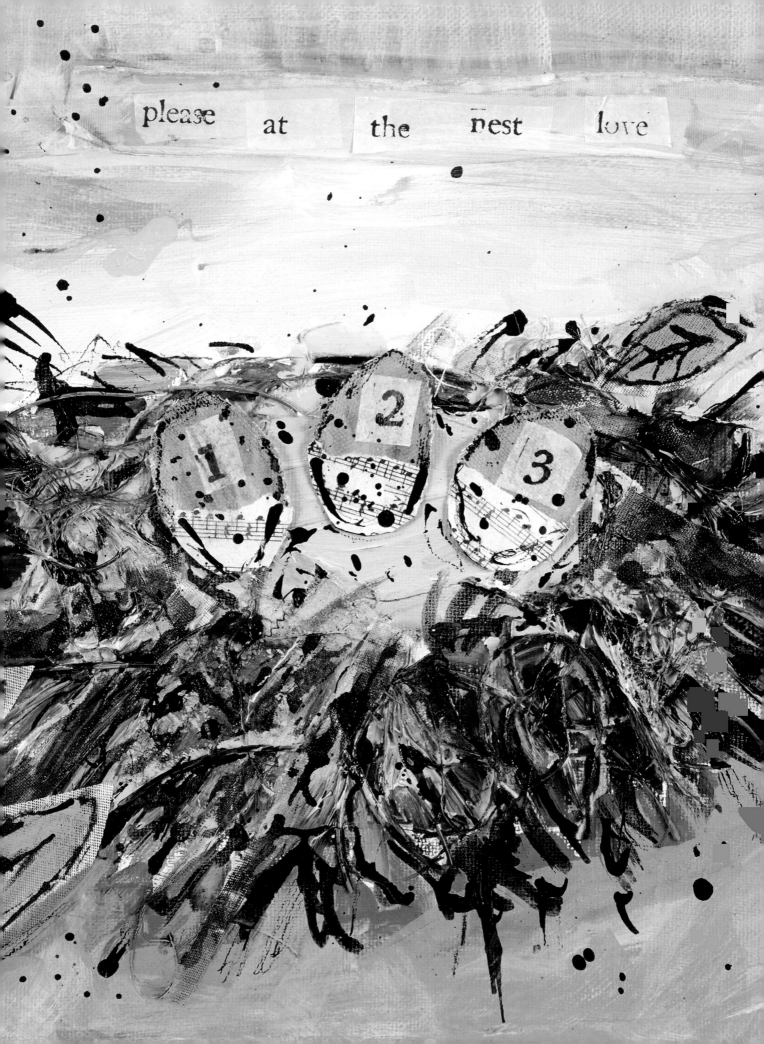

PAPERCLAY AND DRYER SHEETS

Paperclay is a great way to add 3-D elements to your paintings. It's very light when dry, so adhering it on a canvas with gel medium is easy. It also dries white, so collaging over it with dryer sheets or other mediums is a great way to build up a textural surface on a painting. Tissue paper and vintage papers are also great to collage on top of Paperclay. It can be found in any arts and crafts store, with the sculpture or modeling supplies. It is soft and pliable, super easy to work with!

THANK GOODNESS SHE FOUND ANOTHER WAY TO USE DRYER SHEETS. USING THEM TO SOFTEN THE LAUNDRY WAS GETTING RATHER OLD AND PREDICTABLE.

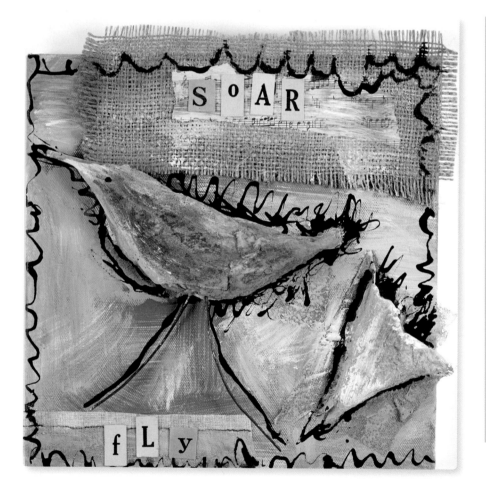

MATERIALS LIST

2" (5cm) chip brush

10" × 10" (25cm × 25cm) stretched canvas

18-gauge wire

acrylic paints and brushes

black ink

burlap

gray and white gesso

heavy matte gel medium

Paperclay

pipette

scissors

sheet music

stitched crinoline

used dryer sheets

vintage letter tiles

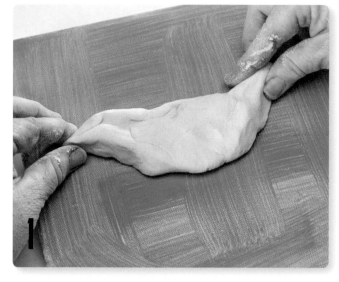

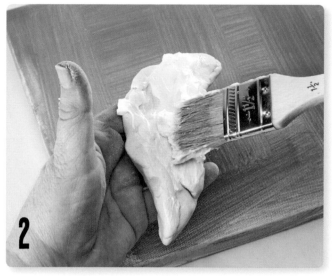

Sculpt the Bird Paint a wash of acrylic paint over the canvas to prepare the background. Let dry. Sculpt a bird shape from Paperclay.

Adhere the Clay to the Canvas Paint the heavy matte gel medium onto the back of the bird and adhere the bird to the canvas. Press firmly to make sure it sticks. Sculpt a small heart shape and apply it the same way.

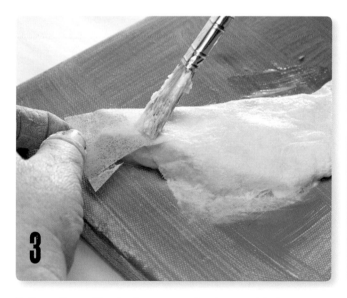

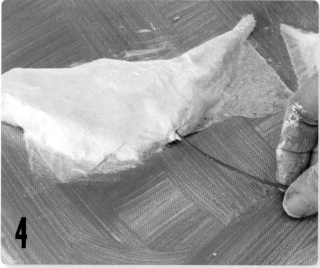

Collage Dryer Sheets Cover your clay forms with dryer sheets (you can substitute crinoline or stitched canvas if you prefer). Adhere the dryer sheet to the clay forms by brushing over the dryer sheets with watered-down gel medium. Make sure to leave an edge of dryer sheet hanging over the form so there is extra laying on the canvas. Glue those extra edges down onto the canvas. Collage a dryer sheet over the sculpted heart in the same way. Let dry.

Add Wire Legs Cut two pieces of 18-gauge wire for the bird's legs. Dip the end of the wire into the gel medium. Place the wire onto the canvas so it adheres to the sculpted bird. Do this for both legs and let them dry.

VISIT CREATEMIXEDMEDIA.COM/COLLAGEPAINTDRAW FOR BONUS DEMONSTRATIONS!

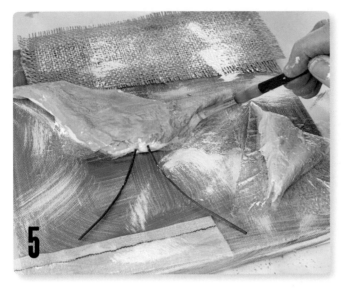

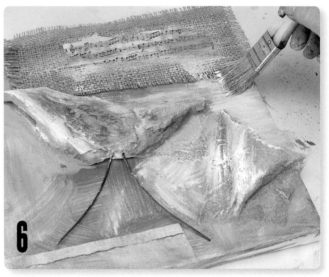

Add Color Collage additional pieces of dryer sheet pieces, burlap and crinoline onto the canvas with gel medium to create texture in the background. Add color to the bird and heart with acrylic paint and a small brush.

Add More Texture Collage a piece of torn sheet music at the top of the canvas with gel medium. Then drybrush gesso and acrylic over the whole piece with the 2" (5cm) chip brush. The gesso highlights the texture of the forms and gives them even more depth as they fly off the canvas.

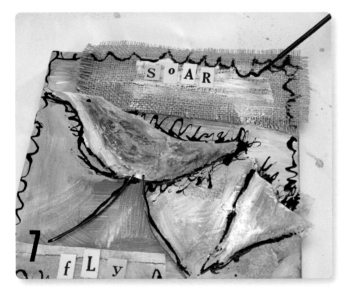

Final Details Select the letter tiles you want to use and adhere them to the canvas with gel medium. Outline the bird and heart shapes with the pipette and black ink, keeping your lines loose. Finish the piece with an inky decorative line that follows the edge of the canvas.

DRYER SHEETS

Dryer sheets are easy to find and stitch, and they add an interesting, transparent texture.

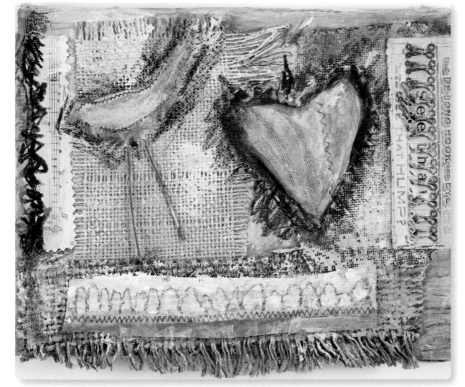

Bird, Heart and Paperclay

This piece also uses Paperclay. Before I began building up my forms, I collaged burlap onto the canvas with heavy matte gel medium. The bird and heart forms were not covered with a dryer sheet but with scraps of crinoline. The vintage sewing hooks were collaged onto the piece as well. The hooks were a new material experiment. I like the way the 3-D forms sit on top of the frayed burlap.

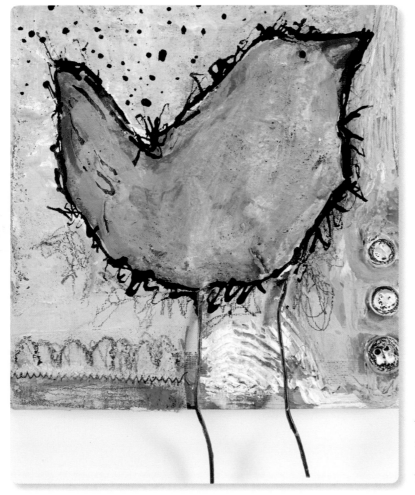

Purple Bird

This piece is another variation of the same technique. I wanted to try a piece where the wire for the legs of the bird were hanging off the canvas.

VISIT CREATEMIXEDMEDIA.COM/COLLAGEPAINTDRAW FOR BONUS DEMONSTRATIONS!

IMPASTO MEDIUM

Impasto medium is a thick textured paste and modeling compound that can be used in a mixed-media piece. It is similar to modeling paste, but I think it has a smoother feel to it. With this piece, I was exploring other ways of adhering fabric to canvas with a medium other than the gel medium. I use it to build up and adhere things to canvas, as well as for a textural background.

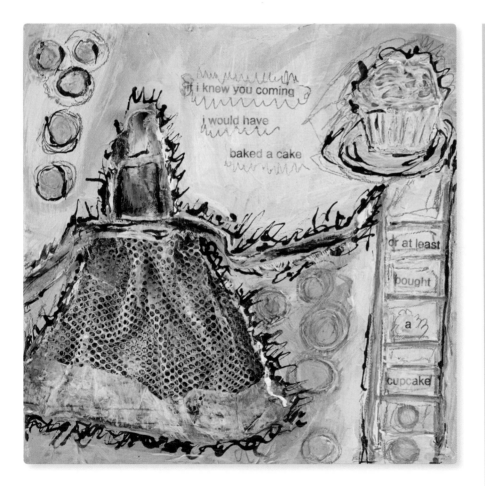

MATERIALS LIST

2" (5cm) chip brush

10" × 10" (25cm × 25cm) stretched canvas

acrylic paints and brushes

black ink

canvas strips

crinoline and lace fabric scraps

heavy matte gel medium

impasto medium

label maker

modeling paste and spreader

pencil

pipette

sandpaper

scissors

vintage pattern paper

water-soluble oil pastels

white gesso

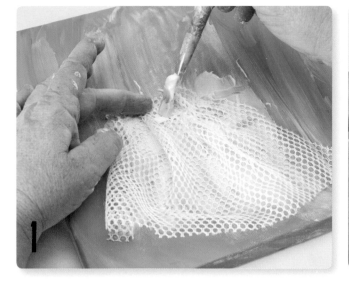

Create the Apron Skirt Paint a canvas with your desired background colors. Let dry. A piece of lacy or mesh fabric works well for this project. Spread some of the impasto medium onto the canvas and lay the edge of the fabric on top. Play with the shape of the fabric. Add a bit of water to your brush and lightly paint on top of the fabric to create the folds of the apron. The impasto medium is rich and creamy and will dry your apron to a rock-solid finish.

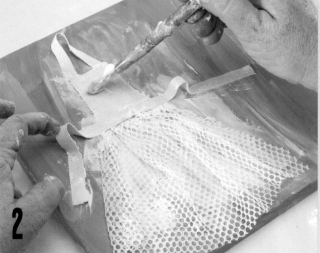

Add the Top of the Apron Create the top of the apron and the straps using strips of unprimed canvas. Place these onto the painted canvas and paint over them with the impasto medium as well. Shape them to add folds and dimension as desired. Let dry.

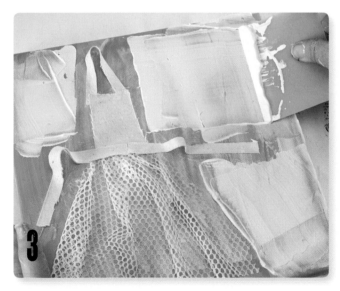

Add Modeling Paste Spread a layer of modeling paste onto the background around the apron. The layer should be thin enough that you can see the paint color underneath, but thick enough to see marks when scribbling and writing into it.

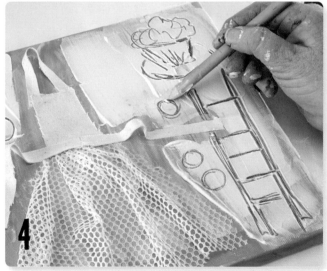

Draw Into the Modeling Paste While the modeling paste is still wet, draw circles, a cupcake and a ladder into the paste with a pencil. Then let dry.

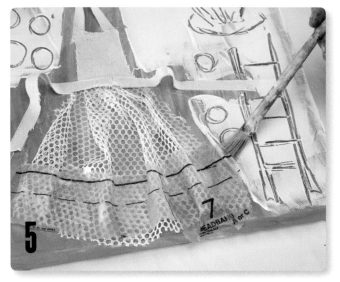

Collage Pattern Paper Cut or tear small strips of vintage pattern paper. Collage them onto the background and the skirt of the apron with the heavy matte gel medium.

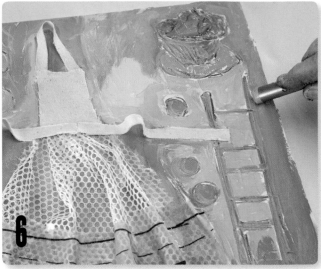

Add Color Paint the first layer of color onto the background with acrylic paint. Add more color and texture to the piece with water-soluble oil pastels.

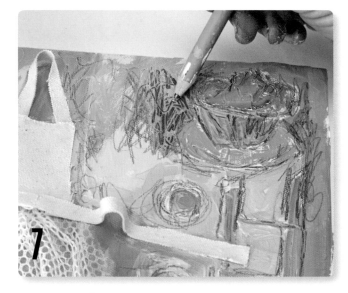

Add Texture Lines Scratch into the wet background paint with a pencil, working around the established shapes again. Keep your lines loose and fun.

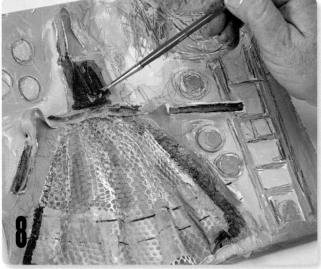

Paint the Apron Continue developing the layers in the background. Then paint the apron fabric with acrylic paint.

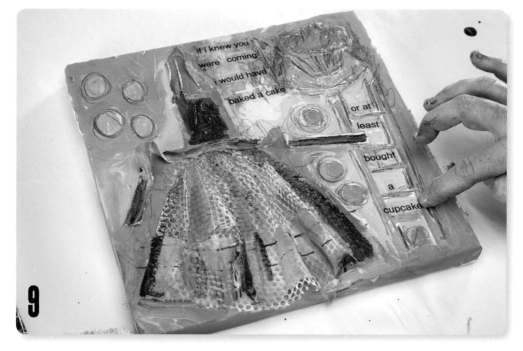

Add Text You can collage individual letters to make up your phrase, but using a label maker to do it is easier. Trim your text to fit and lay it on the canvas where you want it. Adhere the text with gel medium. You can lightly sand over the printed words to take off the sheen.

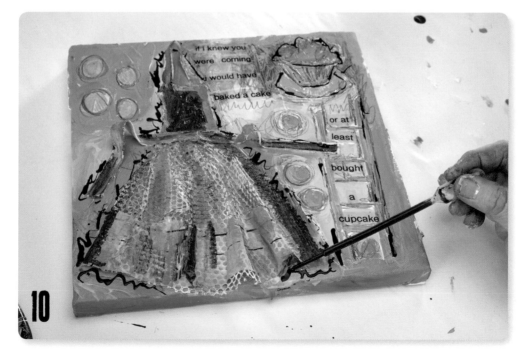

Final Details You can add more texture and layers by drybrushing gesso across the canvas with a 2" (5cm) chip brush if desired. Use the pipette and black ink to loosely outline the apron, ladder and cupcake. Doing so will make them pop.

GESSO AS A MEDIUM AND A BINDER

I love gesso. I love everything about it. I even love the word itself. Have you ever painted something you were not happy with? Gesso over it and start something new. When you drybrush gesso over a piece, it pulls up the texture and softens the colors. I have mixed acrylic paint into gesso when the gesso is handy and the titanium white is not. Whatever works! For this piece the gesso is used as a medium and a binder. The foam core houses were dipped into gray gesso and applied to the canvas. The gesso binds them to the canvas.

A HOUSE IS NOT REALLY A HOME UNTIL IT IS DIPPED IN GESSO.

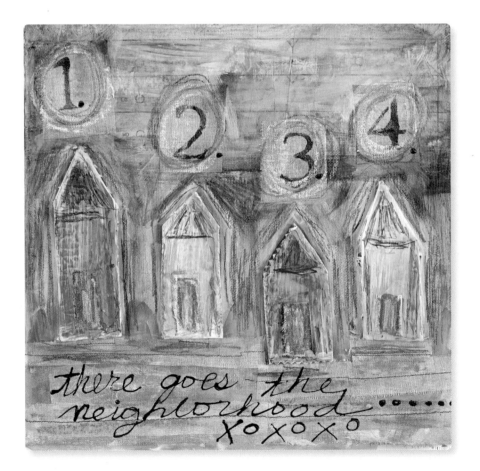

MATERIALS LIST

2" (5cm) chip brush

6B graphite pencil

12" × 12" (30cm × 30cm) stretched canvas

acrylic paints and brushes

black fabric paint

crinoline

foam core

gray and white gesso

heavy matte gel medium

number stencils

water-soluble oil pastels

X-acto or craft knife

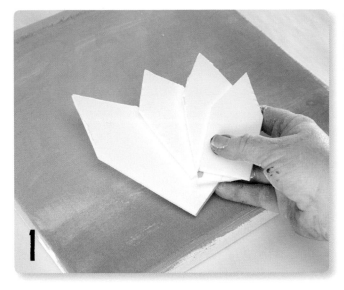

Create the House Shapes Paint a background onto your canvas with acrylic paint and let dry. Using an X-acto knife and white foam core, cut out a row of quirky house shapes. Keep them simple but vary the sizes.

Cover the Houses Paint gray gesso onto the entire foam core house. Cover the whole house, including the back and sides; you don't want any of the white foam to show. Do this for each house.

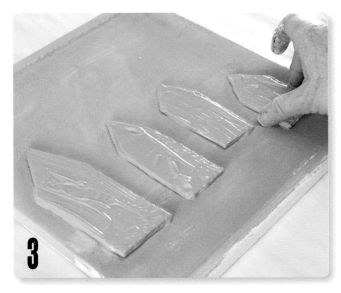

Adhere the Houses to the Canvas Place each of the gesso-covered houses onto your canvas. The gesso helps to adhere them to the piece. Let dry.

Stencil Numbers Cut four pieces of crinoline for the house numbers. Trim down the crinoline to the size you want for each number. Using a number stencil, paint each number onto the pieces of crinoline with acrylic paint.

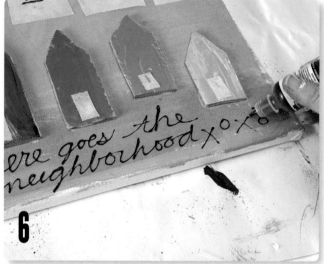

Add Color Add the first layer of color to each foam house with acrylic paint. I chose bright, fun colors.

Use gel medium to adhere each of your stenciled crinoline pieces onto the canvas. Paint another layer of gel medium over each piece of crinoline to seal them.

Add Text Cut small pieces of crinoline to be used as small doors on each foam house. Attach these to the houses with gel medium. While that's drying, use the black fabric paint to write out your chosen phrase at the base of the canvas. Let dry.

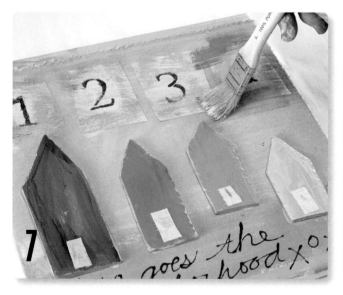

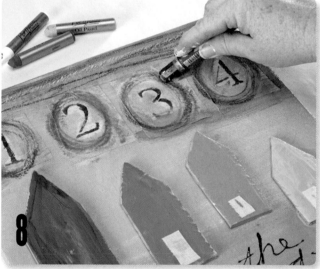

Blend the Numbers Drybrush paint onto the background and over the adhered numbers with a 2" (5cm) chip brush for more texture and to help blend the crinoline. It's good to choose a similar color but a slightly different shade so it will stand out.

Add Texture Add more texture and color to the background and the numbers with the water-soluble oil pastels. Then draw a circular outline around the numbers with the pastels and the 6B graphite crayon.

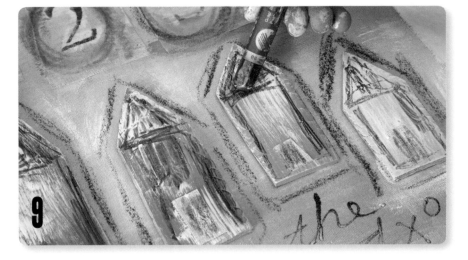

Outline the Houses Lightly drybrush white gesso over the whole background and onto the houses. Then use the 6B graphite crayon to outline the houses and add details.

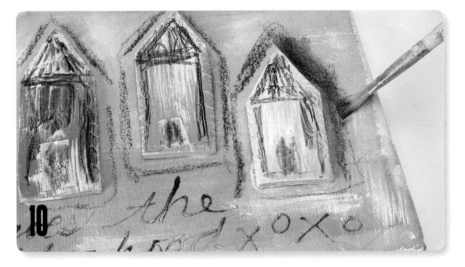

Final Details To finish the piece, go back with a clean brush and a little water to soften the edges of the graphite crayon.

VISUAL INTEREST AND VARIATIONS

Gesso comes in gray, white and black. Try them all! Stitched crinoline is one of my favorite materials for adding visual interest to a piece. Crinoline can be purchased in a fabric store; look in the utility fabrics section. It's easy to add a line of stitching onto the fabric. It's a great way to add texture to your shapes and backgrounds.

SLUDGE NEST

I was literally reading every page of an art supply catalog, as I often do to see what new products are out there. It's the thrill of the hunt; can I find a product that I can use in the way intended or switch things up a bit, experiment and come up with another way to use something? I came across a product called sludge, which is the by-product of acrylic paint, and it is used as a gesso and a binder. It's excellent to spread on a canvas for the first layer. When you work with sludge, not only are you getting your medium vibe on, you are doing it green! I have ordered a few different jars of sludge. Every single one has been a different color, but I like that. It's an art surprise.

SHE LOVED THE IDEA OF A NEST, BUT IF YOU COULD BUILD IT UP WITH WIRE AND CRINOLINE, WELL, IT REALLY DIDN'T GET ANY BETTER THAN THAT.

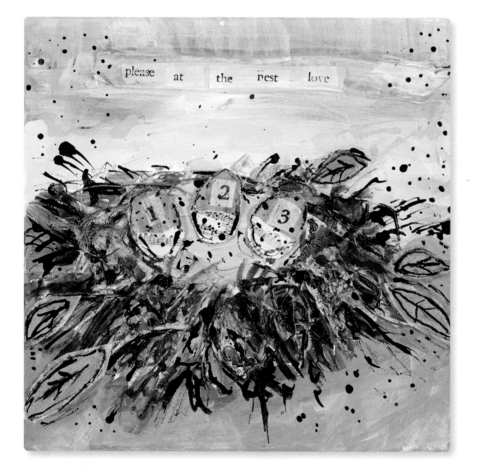

MATERIALS LIST

2" (5cm) chip brush

12" × 12" (30cm × 30cm) stretched canvas

acrylic paints and brushes

black ink

brown fabric paint

canvas and fabric scraps

crinoline

heavy matte gel medium

ink pad

letter stamps

pencil

pipette

sheet music

sludge and spreader

string

tissue paper

vintage letters and numbers

water-soluble oil pastels

white gesso

Cover the Canvas With Sludge Using a spreader, pour a little sludge onto the canvas and spread it. Continue to pour and spread the sludge until you've covered the whole canvas with a thick layer.

Draw Into the Sludge Use a pencil to draw a loose nest shape into the wet sludge. You just want to block out where the shape will be. The sludge in this area needs to be quite thick.

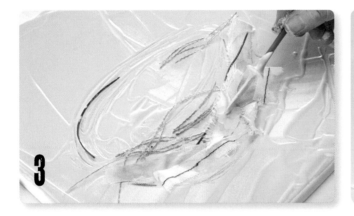

Start Building the Nest While the sludge is still wet, begin applying string, crinoline and strips of fabric to create texture for the nest. You can use any little bits and pieces you want. After all, a nest is built from anything a bird can find! Spread some of the sludge on top of the fabric bits to secure them to the canvas.

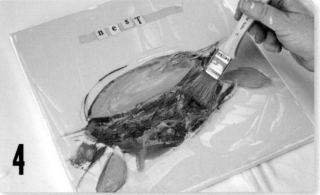

Add Color to the Nest Choose your letter tiles and place them into the wet sludge at the top of the canvas. Add crinoline leaf shapes. Let the sludge dry overnight.

Begin painting the first layers of color into the nest with acrylic paint. You can paint right over the textural pieces that are sticking out.

SLUDGE

Since sludge is a by-product of paint, colors and thickness vary. You get what you get! It's a surprise in a jar. Often I use an old credit card to spread mediums on a painting. I also like to use heavy plastic spreaders I get at the auto supply store. They are inexpensive (usually under a dollar), heavy duty and allow you leverage when applying a thick layer of paint or medium onto your painting.

VISIT CREATEMIXEDMEDIA.COM/COLLAGEPAINTDRAW FOR BONUS DEMONSTRATIONS!

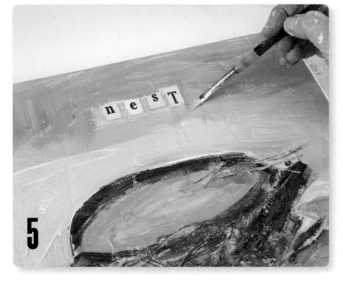

5

Add Color to the Background Paint the background, covering the whole canvas. Choose fun, bright colors. It's OK to mix and blend the colors on the canvas as you paint.

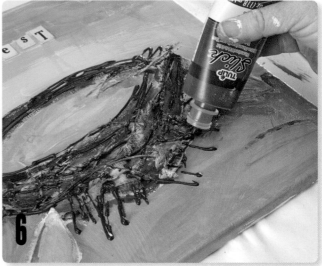

6

Define the Nest Redefine the lines of the nest with brown fabric paint. The lines should be loose and messy, just like the twigs of a real nest. Stay loose and have fun. Don't be too fussy about the details.

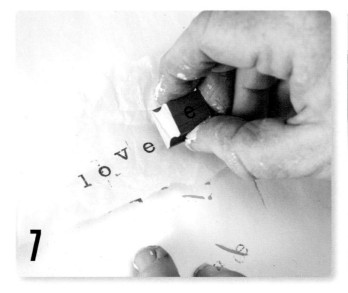

7

Stamp Tissue Paper Stamp letters onto white tissue paper to be collaged onto the canvas. Let the ink dry.

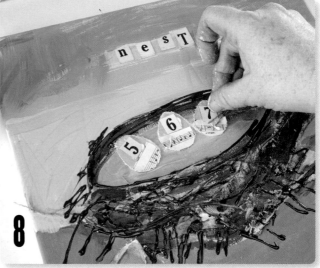

8

Add Eggs to the Nest Time to add more details. Cut out egg shapes from canvas scraps and sheet music. Add color to the top of the eggs with the water-soluble oil pastels. Adhere the eggs in the center of your nest with the heavy matte gel medium. Collage numbers on top of the eggs to finish them.

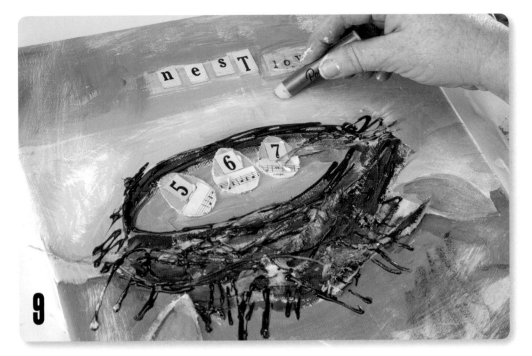

Add More Texture and Color Drybrush a small amount of white gesso over the whole piece with the 2" (5cm) chip brush to give it texture. Let dry. Then add a little more color to the background with water-soluble oil pastels.

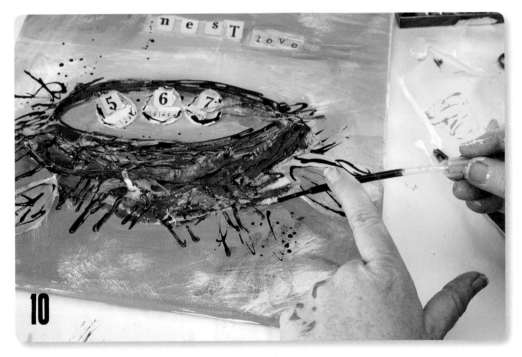

Final Details After the piece has completely dried, further define the nest shape using the pipette and black ink. Fill the pipette with ink and gently tap it over the painting to splatter ink droplets. Trace over the edges of the eggs and the leaf shapes with the pipette.

VISIT CREATEMIXEDMEDIA.COM/COLLAGEPAINTDRAW FOR BONUS DEMONSTRATIONS!

STENCILED PAINTERLY DRESS

The dress is an image that often comes into my work. Again, I am reminded of childhood—party dresses, back to school dresses, dresses to twirl and spin in. As a child I remember reading *The Hundred Dresses* written by Eleanor Estes and illustrated by Louis Slobodkin. That children's book has proven to be a huge source of inspiration to me and my work for years. The story itself is about a girl who draws one hundred dresses because she can't afford them, and that story has stayed with me. So I created a series of vintage inspired dresses for StencilGirl Products. I wanted to show that you can create a very painterly and textural piece of art using stencils.

> **SHE REMEMBERED HER DRESSES FROM CHILDHOOD, AND SHE THOUGHT ABOUT BIRTHDAY PARTIES, BALLERINA BIRTHDAY CAKES AND TWIRLING, LOTS OF TWIRLING.**

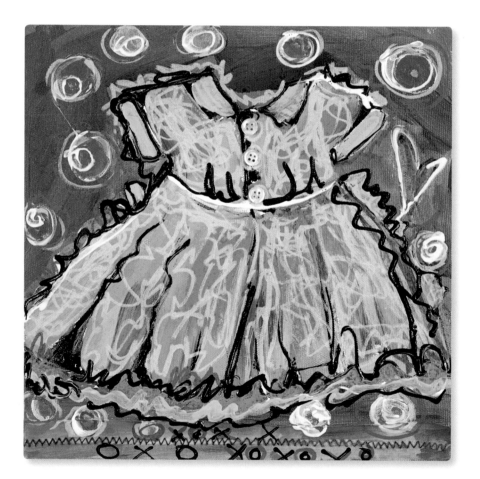

MATERIALS LIST

2" (5cm) chip brush

12" × 12" (30cm × 30cm) stretched canvas

acrylic paints and brushes

black and white fabric paints

dress stencil (StencilGirl Products)

heavy matte gel medium

modeling paste and spreader

vintage buttons

water-soluble oil pastels

white gesso

Stencil the Dress With Paint Using the dress stencil from StencilGirl Products, paint the dress onto the canvas with acrylic paint. Let dry.

Stencil the Dress With Modeling Paste Place the stencil back on top of the canvas, in a slightly different place than before, and apply modeling paste. The stencil does not have to match up with the paint lines for this layer. You want it to be offset from the paint lines you made in step 1. Spread the modeling paste over the entire stencil.

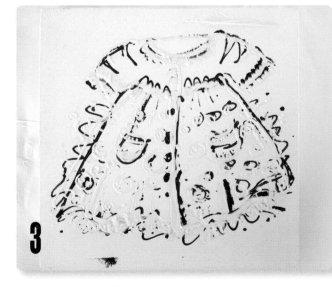

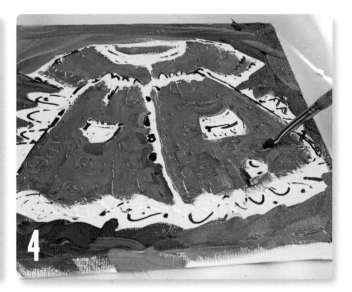

Remove the Stencil Carefully lift up and remove the stencil. Let dry.

Start Adding Color Paint the background around the dress with purple acrylic paint and a small brush. Paint the dress with blue acrylic, using the black stenciled paint lines as a guide. The modeling paste lines show up as texture underneath the color. Let the paint dry.

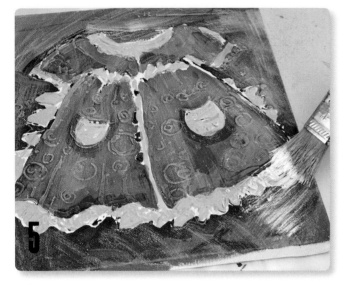

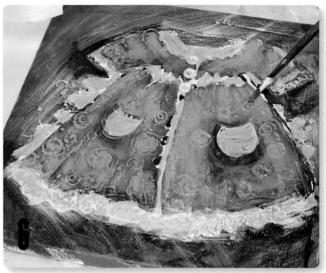

Paint the Dress Details Paint the collar, ruffles and pockets of the dress with yellow acrylic paint. Let it dry. Then lightly drybrush white gesso over the whole piece with the 2" (5cm) chip brush. Let dry.

Add More Color Use the water-soluble oil pastels to add more color and dimension to the dress and background. With a clean, damp brush, smooth and blend the oil pastels. Adhere a line of buttons to the dress with heavy matte gel medium.

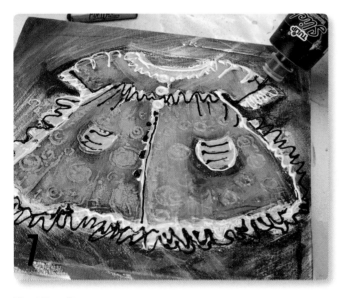

Final Details Finish the piece by outlining the dress and adding more detail with the black and white fabric paints. Keep your lines loose and expressive.

LOOSE LINES

I try to keep my lines and mark making loose, fun and expressive. Sometimes it's easy to do, sometimes it's a challenge. Try not to overwork your lines; lay them down and move on. I do a lot of scribbly lines, because you really can't go wrong with them. It is almost primal. Add outlines, lots of outlines. You would be amazed at what a loose outline can do for a piece.

I think because I am so inspired by the art of kids, whom I observe drawing and painting with such freeness and joy, I try to capture that in my work. Don't use a pencil. Think like a kid with no eraser—just go for it!

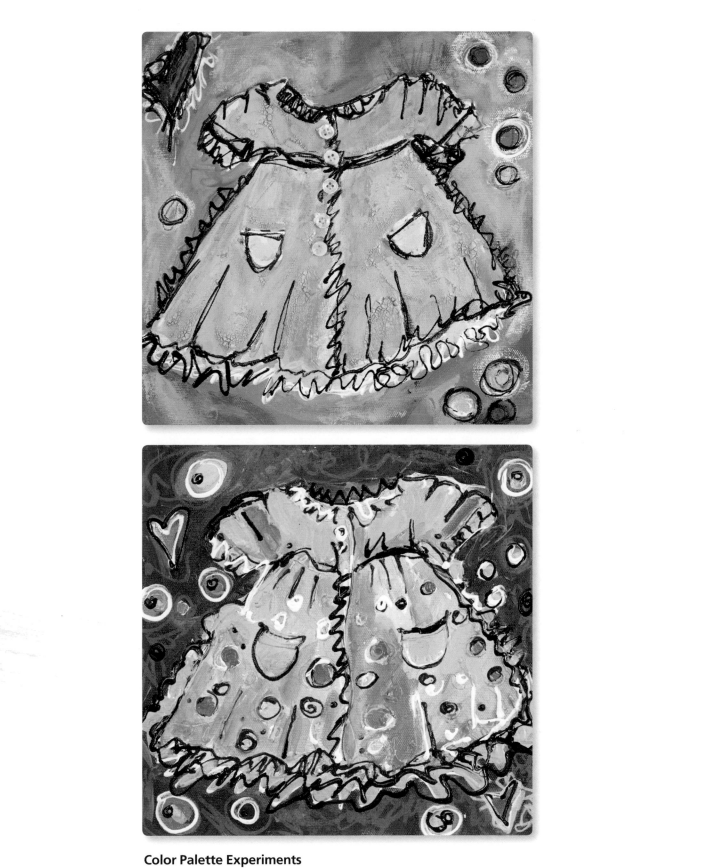

Color Palette Experiments
When I paint I always work on more than one piece at a time. I usually lay out three canvases at a time and have a go at them. I may use the same imagery, but I love to see how various color combinations will change up a painting.

DON'T RESIST THE RESIST, JUST GO WITH IT

It all goes back to that blank white canvas. We all have to start somewhere when we create. Often that first brushstroke or pencil line is the most intimidating. It is to me. I believe that is why I try to come up with new ways to eliminate a blank canvas staring me in the face. It could be as simple as covering the canvas with a layer of pattern paper or using a few strips of frayed canvas to begin blocking out my paintings. But there has to be something on that canvas. Modeling paste is a favorite of mine. Although you still have a white canvas, if you smear on the modeling paste, you can draw into it, stick things into it and at the very least have a very textural, painterly surface to *begin* your painting on. As far as an outline or a resist goes, I like using these techniques because they do not allow total control over how the piece is going to come out. I usually find that if it turns out not exactly how I want it to turn out, it can push me in a new direction, lead me to a new idea or provide a new twist on the imagery. I love when things take an unexpected twist and push me outside my comfort zone. As always, try to put the *mixed* back into mixed media. Explore and experiment!

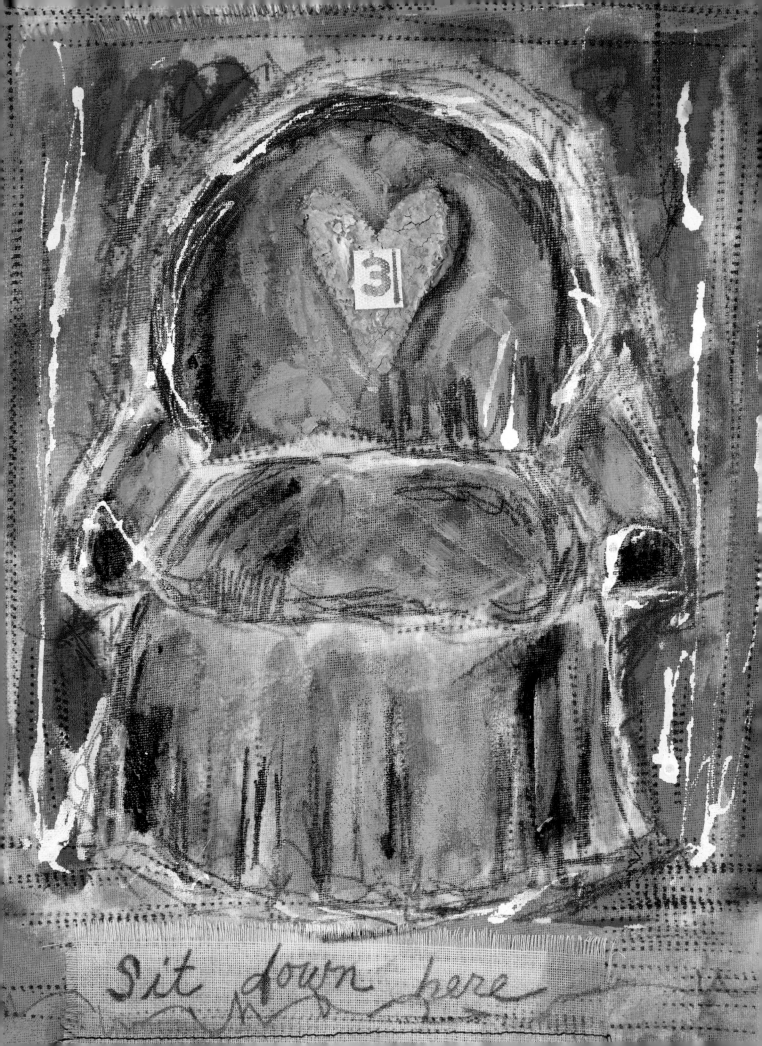

PACKING TAPE PHOTO TRANSFER

I am drawn to this one particular photo of my kids when they were small. I have it framed in my home, and I have used it in my art. I love the simplicity of the packing tape transfer. I also love that when you rub the photo off the tape, the results are a bit unpredictable. The transfer will have an aged, vintage quality to it that goes hand in hand with my work. I love the fact that with this painting I was able to combine the image of my kids with a representation of the house they were raised in since it was a green house with purple shutters.

SHE LOVED HER KIDS MORE THAN ANYTHING ELSE. TO SAVE THEIR IMAGE IN A PAINTING WITH PACKING TAPE MADE HER HAPPY BECAUSE THE TECHNIQUE WAS SIMPLE AND PURE.

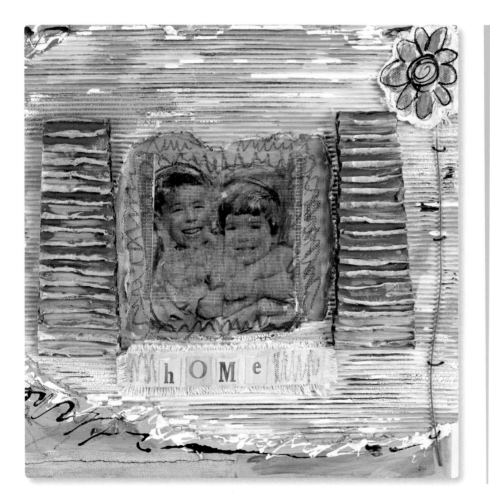

MATERIALS LIST

2" (5cm) chip brush

12" × 12" (30cm × 30cm) stretched canvas

18-gauge wire

acrylic paints and brushes

black fabric paint

corrugated cardboard

gold metallic marker

heavy matte gel medium

packing tape

photocopy of a picture (not ink-jet)

pipette

scissors

scraps of fabric (canvas, crinoline, scrim)

vintage letter tiles

white gesso

white ink

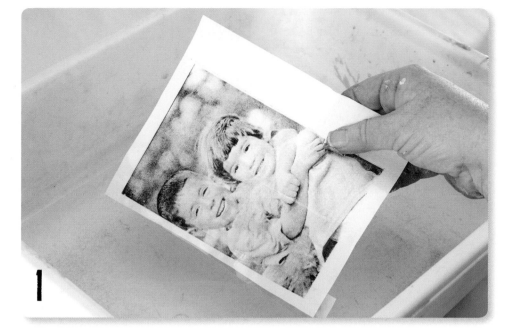

Print and Tape the Photo Print a photo to use for this project. Make sure the photo you use isn't printed on an ink-jet printer. An ink-jet photo won't stick to the packing tape. A Xerox or toner-printed photo works best. Once you have your chosen photo, cover the top of it with strips of packing tape (line up the strips side by side). Burnish the taped image to help the ink transfer (use your fingers, a spoon or burnishing tool). Then put the image in warm water to soak.

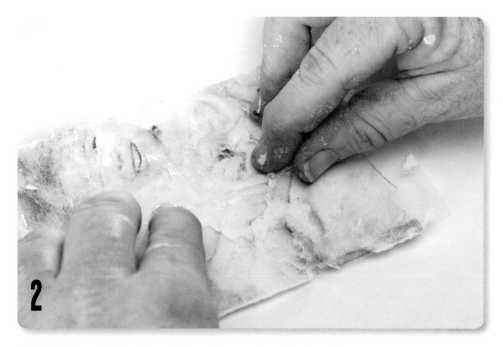

Peel the Paper Off Gently peel the wet paper from the tape. You can choose to leave some of the paper on or take most of it off. Voilá, instant easy transfer. The image remains on the tape!

VISIT CREATEMIXEDMEDIA.COM/COLLAGEPAINTDRAW FOR BONUS DEMONSTRATIONS!

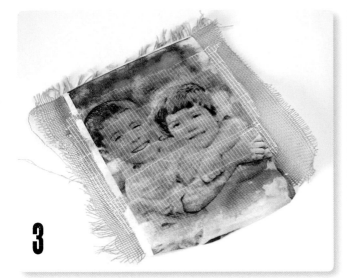

3

Mount the Photo Transfer Mount the transferred photo onto some scrap fabric with the heavy matte gel medium. This gives a nice addition of texture beneath the image.

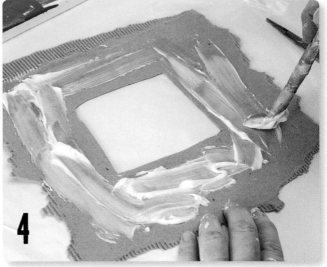

4

Cut and Adhere Cardboard This piece calls for a different type of texture: a rough, old farmhouse kind of texture. Corrugated cardboard is perfect. Cut out a window from the center of the cardboard. This will frame the transferred photo. Apply gel medium to the cardboard and adhere the cardboard to a prepared canvas.

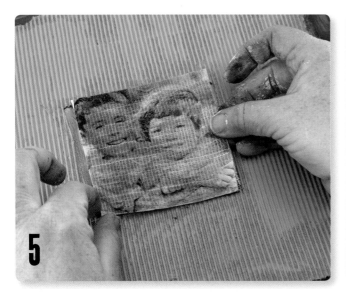

5

Add Color Paint over the corrugated cardboard and inside the cut-out window with acrylic paint. Let dry. Then trim the edges of the photo transfer and adhere it inside the window with gel medium.

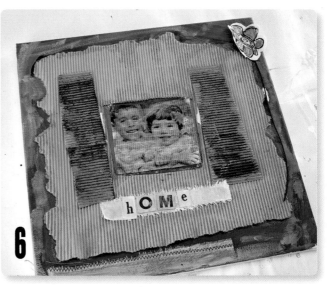

6

Continue Adding Color and Detail Choose a few letter tiles and adhere them to a strip of unprimed canvas. Then attach that canvas strip to the cardboard with gel medium. Cut two more pieces of cardboard and adhere them on either side of the photo transfer. Add color to the canvas strip and the new cardboard pieces with acrylic paint. Cut out a flower shape from unprimed canvas and cut a piece of wire for the stem. Paint the flower, then add petal details with black fabric paint. Let dry.

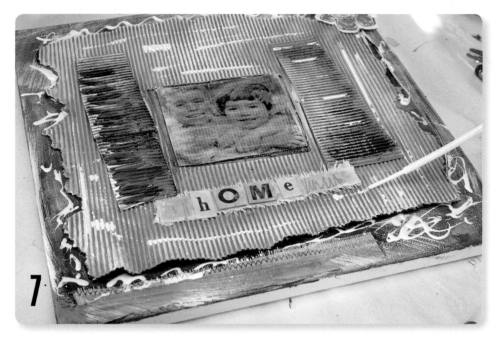

Add Ink Lines Adhere the canvas flower and the wire stem to the canvas with gel medium. Drybrush white gesso over the whole piece with a 2" (5cm) chip brush. Then add white ink lines with the pipette for more texture.

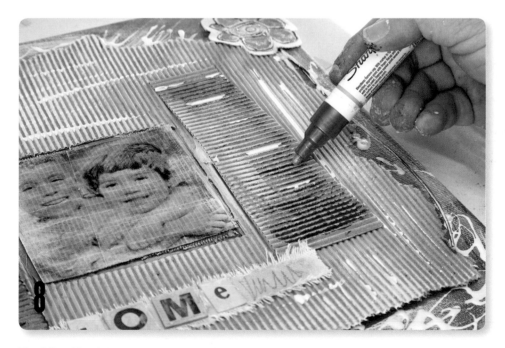

Final Details Finish the piece by adding details with a gold metallic marker.

CARBON PAPER TRANSFER

I'm always on the search for new materials to use in my art. I was walking through an office supply store when I saw a package of carbon paper. I immediately thought of the days when teachers did their worksheets with carbon paper. I had to pick up a pack and give it a try.

I like using this technique to transfer an image because using the tracing wheel with the carbon paper gives you a different line. I try to keep things loose and not perfect or overworked, and this allows for imperfection. By pressing down hard with the tracing wheel you are getting an outline on your canvas, but it may be a little off or askew, and I like that in a piece. You are also getting a very textural line, and of course I love that!

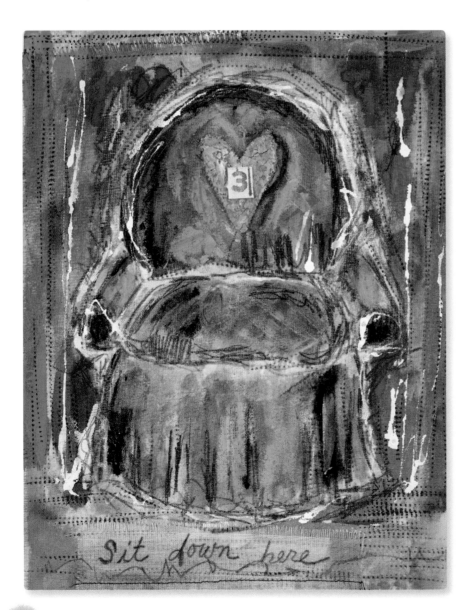

MATERIALS LIST

6B graphite crayon

9" × 12" (23cm × 30cm) stretched canvas

acrylic paints and brushes

carbon paper

cardboard

crinoline

heavy matte gel medium

pencil

pipette

scissors

tracing wheel

vintage number tiles

white ink

Sketch the Chair Prepare your background by adhering a piece of crinoline to the canvas with gel medium. Paint over it with acrylic paint and let dry. Using a hard surface to lean against, draw the big, comfy chair onto a separate piece of crinoline. Place the carbon paper onto the canvas with the carbon side down. Lay the crinoline with the chair drawing on top of the carbon paper.

Transfer the Drawing Using a tracing wheel, trace the drawing of the chair, pressing firmly. The carbon paper transfers the drawing onto the canvas and creates textured lines. You can carefully lift up a corner of the carbon paper to see if the lines are transferring. Trace over the lines again if they aren't dark enough.

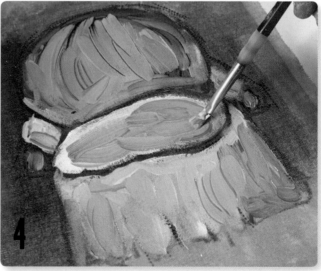

Define the Lines Once all the lines have transferred, remove the carbon paper. You'll find textured lines on the canvas. Go over these lines with a 6B graphite crayon to further define the shape of the chair.

Paint In the Chair Add the first layer of paint to the chair. Use a small brush and acrylic paint. It's OK to mix the colors on the canvas as you're painting. The colors don't have to be uniform. Have fun and experiment!

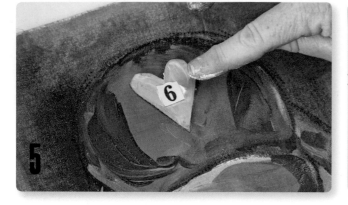

Add Heart Detail Cut a heart shape out of cardboard and paint it a contrasting color. Attach a number tile to the cardboard heart using the gel medium. Then use the gel medium to adhere the heart shape to the canvas in the center of the chair.

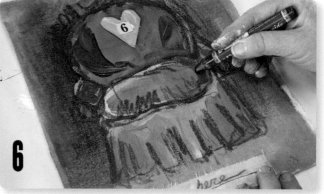

Further Define the Chair Cut a strip of crinoline to collage onto the base of the canvas. Adhere it with gel medium and let dry. Write your chosen phrase onto the crinoline with a pencil. Go back over the chair with the 6B graphite crayon, adding more texture and further defining the shape.

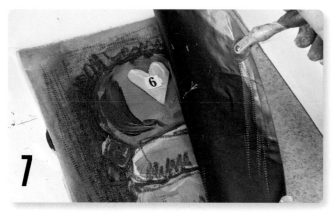

Add More Textured Lines Place the carbon paper over the canvas again, carbon side down. Using the tracing wheel, press firmly to transfer textured lines onto the background for more visual interest.

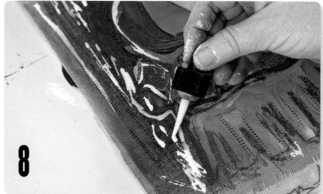

Final Details To finish the piece, paint white ink onto the background and the chair with a small brush or the ink stopper.

CARBON PAPER

While you are using the carbon paper, keep lifting it up to make sure your lines somewhat match up to parts of your original transferred image (like the fabric folds at the bottom of the chair).
The tracing wheel tool and the carbon paper provide such an interesting look, you may not know when to stop. Sometimes less is more, but sometimes more is better. Do what feels right to you.

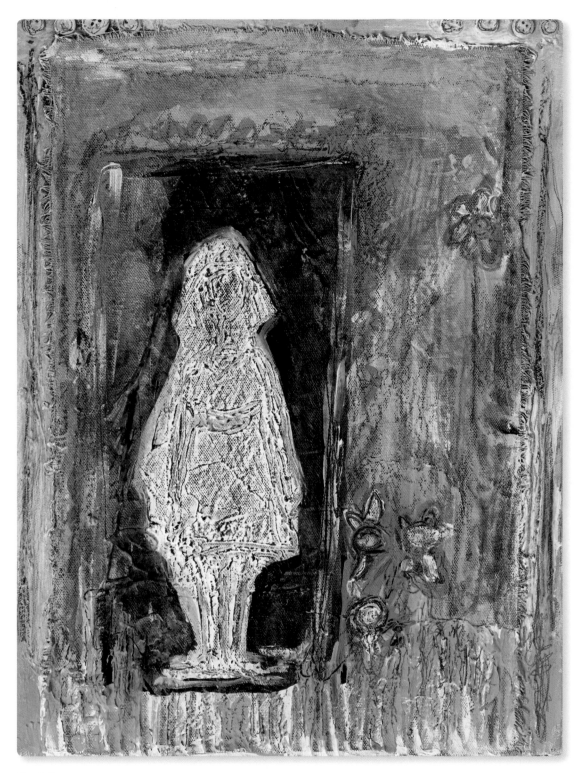

Dark Day

For this piece, I collaged and painted a background onto canvas.
The figure was created by drawing into wet modeling paste. I
let the modeling paste dry completely. Then the carbon paper
was placed down and rubbed over the very textural figure. I
was going to go into the figure with paint, but I ended up liking
the way the white modeling paste contrasted with the carbon
paper. It reminded me of a gestural drawing.

LOOSE INK TRANSFER

I love to add ink to my work. Ink has a different feel and flow to it than paint when added to a mixed-media painting. It tends to be a bit unpredictable. Perfection is overrated, so ink allows for some "happy accidents." Embrace them. If it drips or moves in a different direction, that is part of its beauty. Using a small brush or a dropper to add some ink to wet acrylic is a great way to mix your materials in a nontraditional way. Remember to embrace the unpredictable!

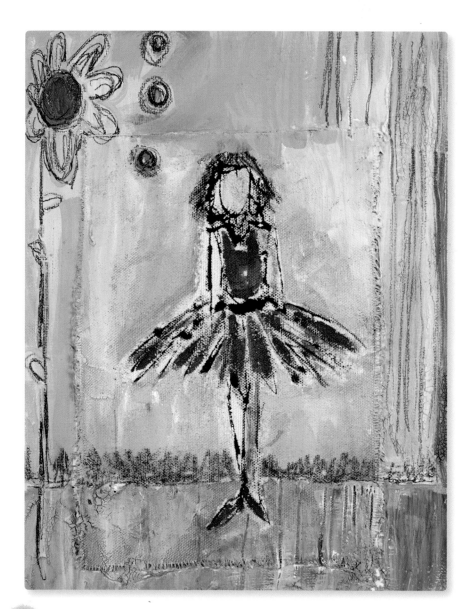

MATERIALS LIST

2" (5cm) chip brush

9" × 12" (23cm × 30cm) stretched canvas

acrylic paints and brushes

black fabric paint

black ink

heavy matte gel medium

index card

pencil

pipette

unprimed canvas

white gesso

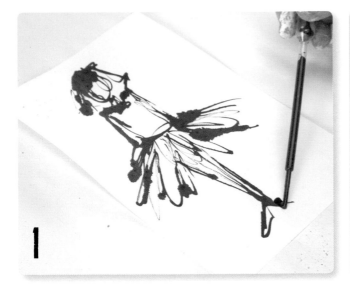

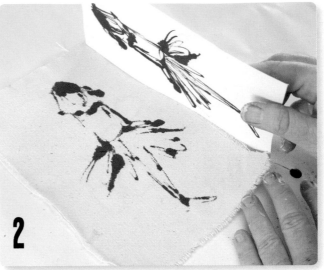

Sketch the Figure For this piece, have several pieces of unprimed canvas so you can play with this transfer technique a few times. Use a pipette and black ink to sketch a simple figure onto an index card. Make sure you use enough ink that it will transfer onto your canvas but not so much that it runs all over the page.

Transfer the Ink While the ink is still wet, press the index card into a strip of canvas. Press down firmly to make sure the ink transfers. Try this several times until you are happy with one of your transfers. You want most of the image to transfer to the canvas strip. Imperfections are a good thing, so try not to overwork it.

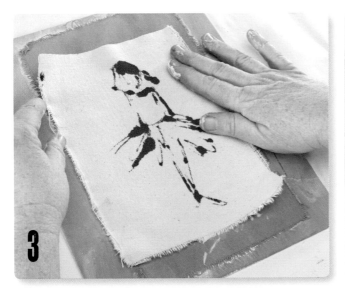

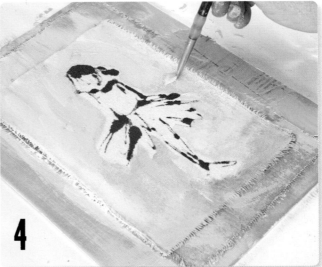

Create the Background For an added layer of texture, adhere an unprimed piece of canvas to the background with the heavy matte gel medium. Then cover the whole background with acrylic paint, choosing a limited, tonal palette (I'm using blues and greens). Let dry. Brush gel medium onto the back of the printed canvas piece and adhere it to the main canvas.

Add Color Around the Figure Paint over the printed canvas with acrylic paint. Choose the same type of colors as the background but in different shades (these blues and greens are brighter than the ones used in step 3). Blend the new colors into the background, unifying the piece.

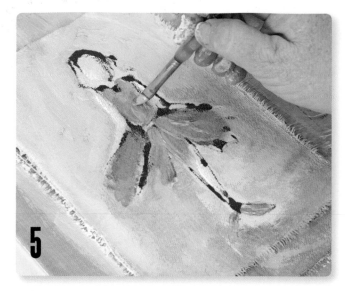

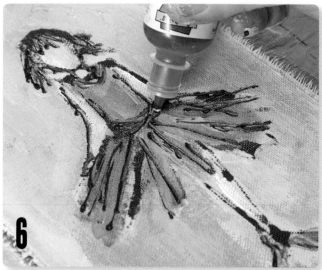

Paint the Figure The figure is beautiful and simple as it is, so just add a splash of color with a small brush and acrylic paint. Be sure to leave some of the ink lines visible.

Outline the Figure Use black fabric paint to bring out the ink lines and add dimension to the figure. You can also use the fabric paint to create shapes and lines in the background. Let dry.

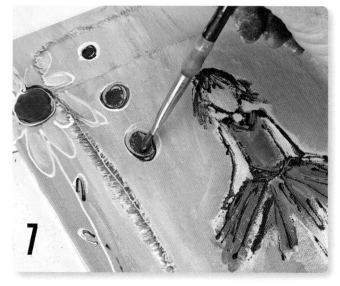

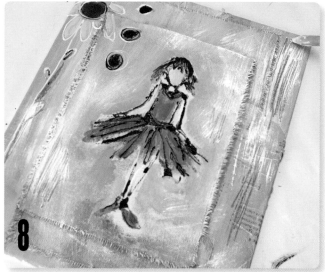

Add More Color Fill in the background shapes with acrylic paint. Choose bright and fun colors.

Final Details Drybrush white gesso sporadically in the background with a 2" (5cm) chip brush. Finish the piece by adding texture in the background with a pencil.

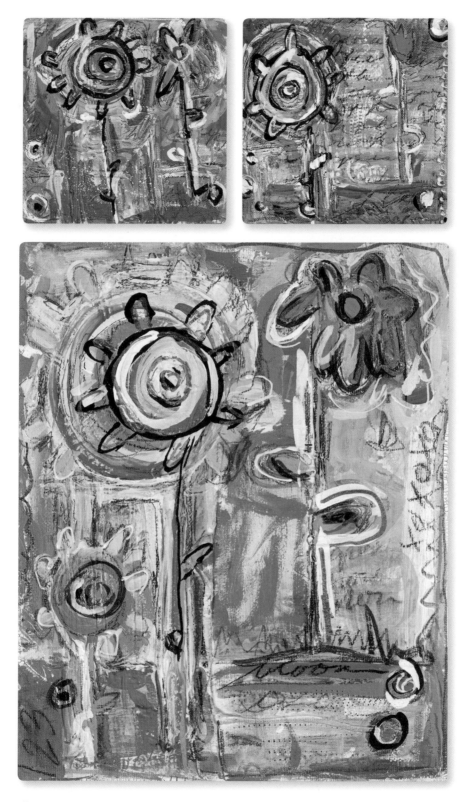

Bloom Where You Are Planted

For this ink transfer the basic flower shape was inked
onto an index card and stamped onto each canvas several
times. I went into each piece with paints, more ink and
metallic marker. Each piece stands alone, but together a
garden is born!

MASKING FLUID RESIST

Masking fluid is traditionally used to block out areas in watercolor paintings. Where the fluid goes, the paint will not. It has the consistency of rubber cement, so when everything dries you rub off the fluid. I use it on paper and fabric, laying down a thick layer. Make sure it has plenty of time to dry before painting over it.

Perhaps watercolor painters would not agree about using the product this way, but I believe with mixed media you should try materials in different ways and push boundaries. Don't be afraid to break the rules.

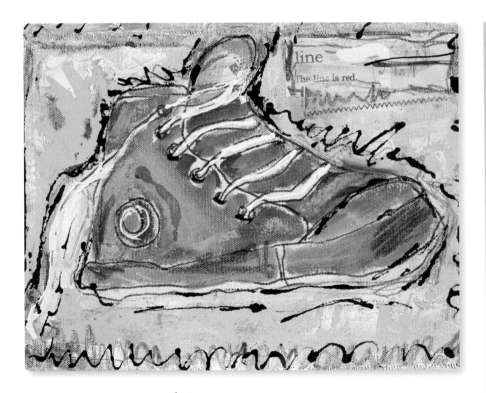

MATERIALS LIST

6B graphite crayon

12" × 12" (30cm × 30cm) stretched canvas

acrylic paints and brushes

black ink

crinoline

gray and white gesso

heavy matte gel medium

masking fluid

permanent black marker

pipette

unprimed canvas

vintage book pages

white fabric paint

yellow ink

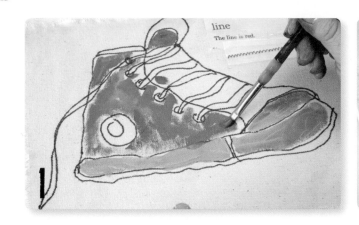

Draw the Shoe Create a contour line drawing of a high-top sneaker on unprimed canvas using a permanent black marker. Adhere the drawing to your main canvas with gel medium.

Collage strips of crinoline and text onto the background with gel medium. I used text from a vintage children's book, but you can use any type of text you want. Begin painting the shoe with very watered-down acrylic paint.

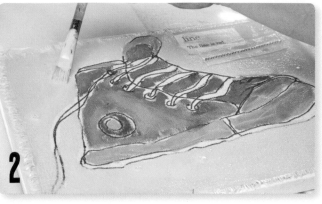

Color the Background Finish painting the shoe with watered-down acrylic. Then paint the entire background with yellow ink. Let dry.

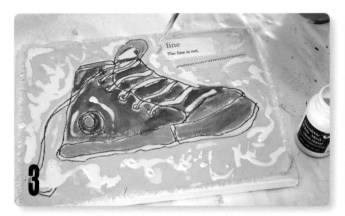

Add Masking Fluid Once the ink and paint are dry, paint masking fluid onto the canvas wherever you want to preserve the color. Let the masking fluid dry completely.

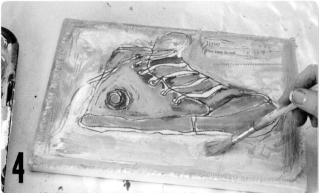

Drybrush Gesso Drybrush white and gray gesso over the shoe and background, covering the masking fluid. Let the paint dry.

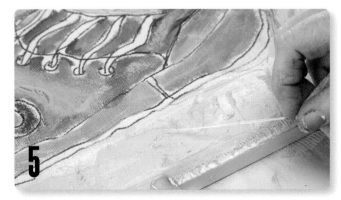

Remove the Masking Fluid Once the gesso is dry, peel off the masking fluid. The color beneath the masking fluid is revealed.

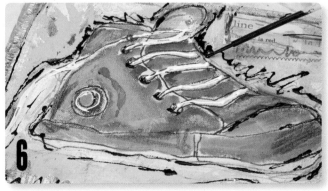

Final Details Scribble in the background with the 6B graphite crayon. Use the white fabric paint to give the shoelaces dimension. With black ink and a pipette, go back and add even more texture to the background. Finish the piece with a loose ink outline around the shoe.

MODELING PASTE AND STENCILS

For this piece, I wanted to depict a chair that was reminiscent of the kindergarten chairs from years ago. However, I wanted the chair to be a relief. In other words, I wanted it to be formed on the canvas. The chair I imagined would be so dimensional that you would feel like you could just sit on it and have a glass of milk and a cookie.

SHE REMEMBERED THE KINDERGARTEN CHAIRS, ALL LINED UP IN A ROW UNDERNEATH THE CHALKBOARD. SHE NEVER ATE THE PASTE, BUT SHE KNEW THOSE WHO DID!

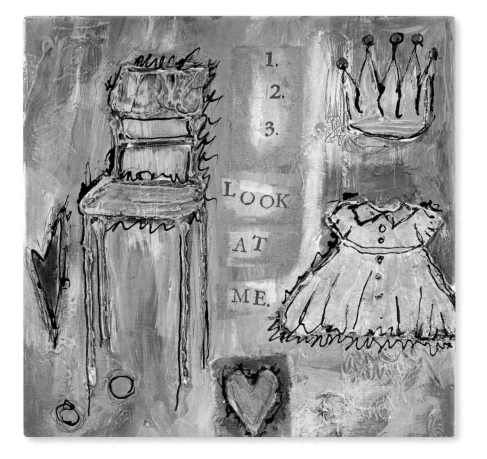

MATERIALS LIST

2" (5cm) chip brush

12" × 12" (30cm × 30cm) stretched canvas

acrylic paints and brushes

black fabric paint

cardboard

crinoline

dress and crown stencils from StencilGirl Products

heavy matte gel medium

ink pad

letter and number stamps

modeling paste and spreader

plastic icing dispenser

scissors

tissue paper

unprimed canvas pieces

white gesso

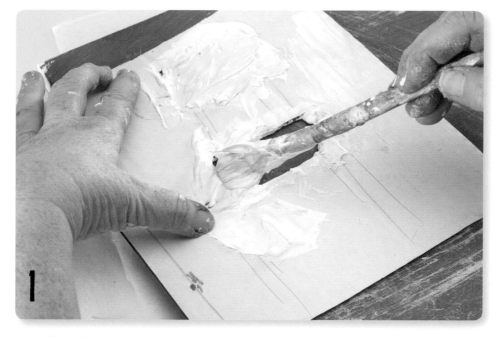

Stencil the Chair Prep your canvas by painting the desired background color with acrylic paint. Let dry.

Create a stencil for the back and seat of the chair using cardboard. Lay the stencil on the canvas and apply a thick layer of modeling paste. Carefully lift off the stencil and allow the paste to dry.

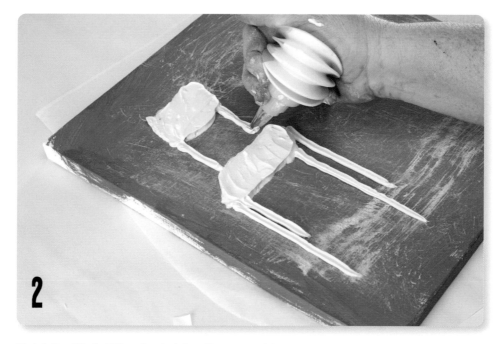

Finish the Chair Fill a plastic icing dispenser with modeling paste and draw thick lines onto the canvas for the legs of the chair. Let dry.

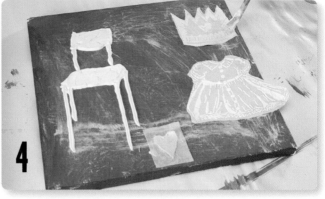

Stencil the Crown and Dress Cut pieces of unprimed canvas for the crown and dress. Spread modeling paste over each stencil to create your outline. Gently lift the stencil off and let the paste dry.

Add the Stenciled Art to the Canvas Trim away the excess canvas around the stenciled designs. Collage the crown and dress onto the canvas using the gel medium. Cut a heart shape from canvas, then adhere it and a small piece of crinoline to the bottom of the piece.

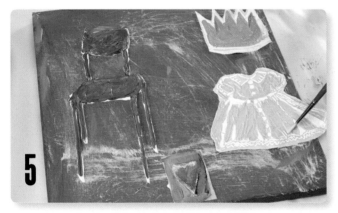

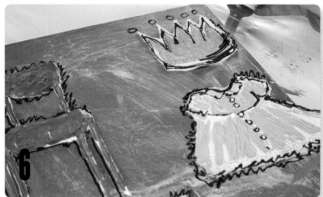

Add Color Add layers of color onto the chair, crown, dress and heart with acrylic paint.

Outline the Shapes Use the black fabric paint to go back and better define the outlines of the objects. Add details like the circles above the crown and the outline around the dress buttons. Stay loose and free with your shapes.

CHOOSING IMAGES

The playfulness of this piece comes through my choice of imagery. As random as these images may seem to be, they work as a cohesive painting because they are all bits and pieces from my childhood. Be true to your imagery! Your artwork will feel authentic because it comes from your heart.

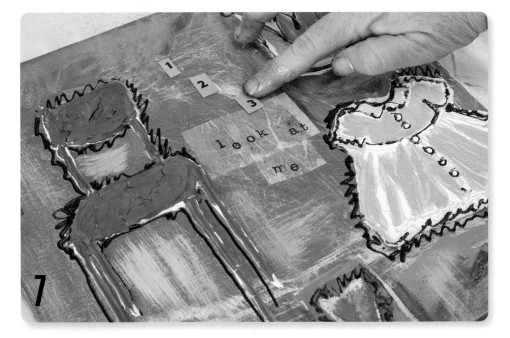

Add More Layers Continue painting layers of color onto the background, keeping it playful. Stamp a phrase and a few numbers onto tissue paper. Trim down the tissue paper phrase and adhere it to the canvas with watered-down gel medium. Trim down the numbers and adhere them as well.

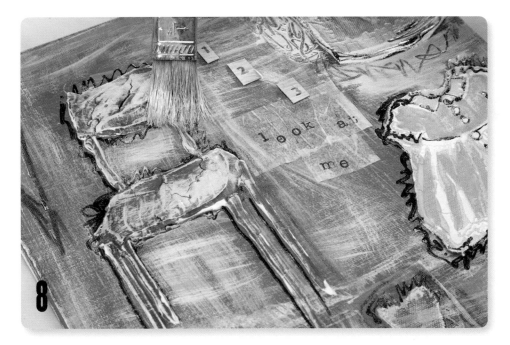

Final Details Drybrush white gesso over the entire piece with the 2" (5cm) chip brush to add texture and finish it.

OFF THE
BEATEN PATH

All right, I admit it. I wander the aisles of hardware stores searching for materials I can use in my artwork. I tend to shop the smaller mom-and-pop hardware stores, rather than the large chains, so I can support small businesses. When I make a purchase from my local hardware store up the street, they always ask, "So what are you going to do with this?" When I tell them, they smile and say, "Oh, never sold one of these to be used that way before!" I find that very endearing. For me part of my process is the local hardware store. It is just a good fit.

This chapter focuses on some of the products and materials I have found in hardware stores and used in my work. I never said I was a purist when it comes to painting! I tend to mix things up and use many mediums and fabrics to layer my work. That said, one of the common denominators in my work is the heavy use of matte gel medium. I layer so much of that stuff on my art that the wire, dresses, cement hearts and ceiling glitter will be on that canvas for a long, long time.

So look beyond the art store. Search the hardware stores. Even if you are not comfortable using materials that are nontraditional, give yourself the chance to play and experiment with them. Again, your artwork is a path and a journey. Embrace it and give yourself permission to play.

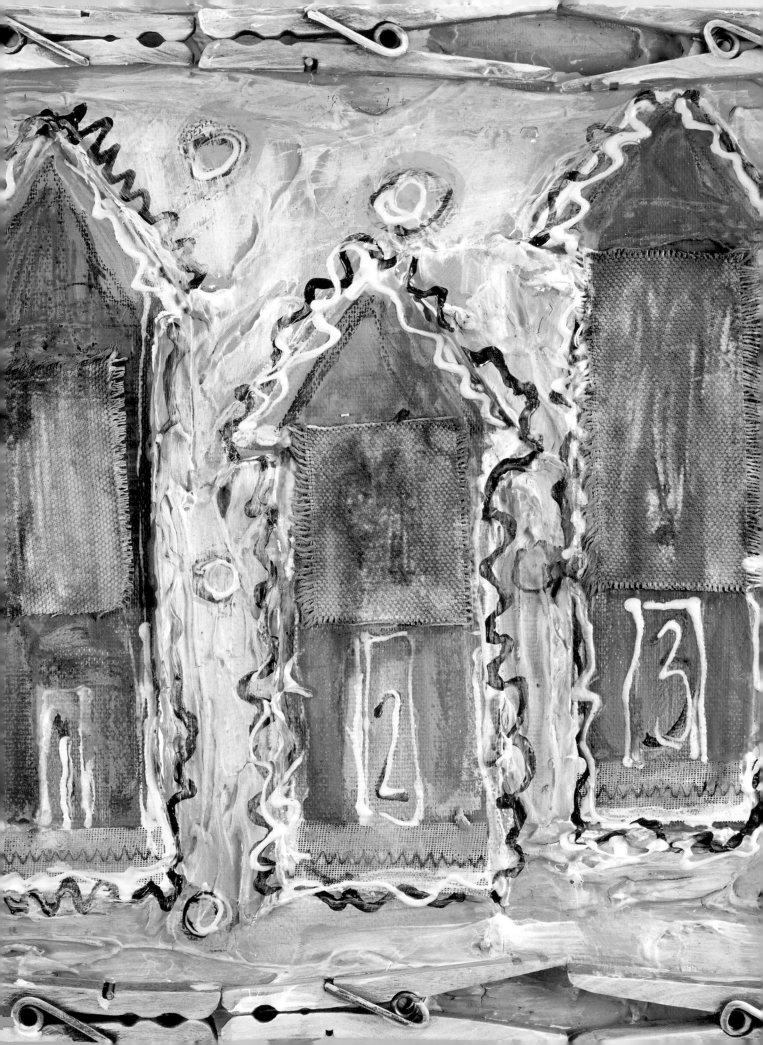

HVAC TAPE

HVAC tape is an aluminium repair tape used in plumbing and heating systems. I saw a roll of it while wandering the plumbing aisle (I know I should probably get some sort of a life) and thought it may be something interesting to add to a mixed-media piece. I do repousse with my third grade art students (repousse is metal tooling, drawing into a soft metal with a pencil or stylus), and I thought the HVAC tape could be a similar way to add visual texture to a piece. It gives a nice raised line. If you use an ink wash on top of it, the ink fills in the grooves. I like using it as opposed to a sheet of metal because it is thin and easy to collage into a painting. Again the wonders of the hardware store!

SHE ALWAYS WANTED A BRIGHT RED PICKUP TRUCK. SOON SHE WILL GET ONE.

MATERIALS LIST

2" (5cm) chip brush

10" × 10" (25cm × 25cm) stretched burlap canvas

acrylic paints and brushes

black ink

black permanent marker

color shine spray

crinoline

heavy matte gel medium

HVAC tape

pencil

red ink

scissors

sketch paper

tracing wheel

vintage letter tiles

white gesso

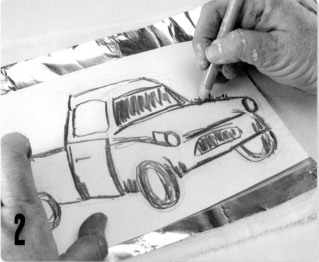

Lay Down Strips of HVAC Tape Sketch the truck shape onto a piece of sketch paper. Cover a piece of crinoline with strips of HVAC tape. Make sure you cover enough of the crinoline with the tape so that it can accommodate the size of your drawing.

Transfer the Truck Sketch Place your sketch on top of the taped crinoline. Draw over your sketch, pressing hard to make an impression into the tape beneath.

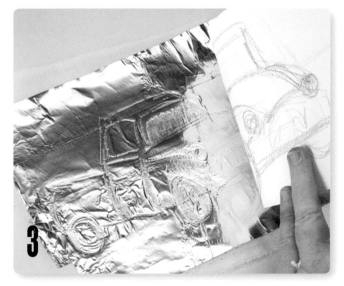

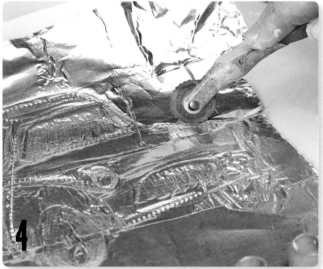

Reveal the Transfer Carefully lift up the sketch to reveal the lines on the tape. If any lines are missing, lay the sketch down in the same place and draw over it again.

Define the Transfer Lines Go back over the lines of the truck with a tracing wheel to better define them and give them a unique texture.

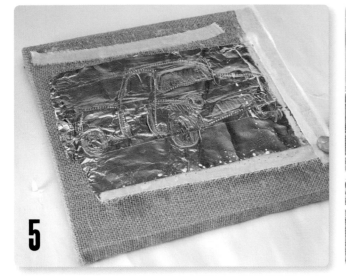

5

Adhere the Transfer to the Canvas Trim down the edges of the taped crinoline. It doesn't have to be perfectly straight or neat, but it needs to fit the canvas. Attach the taped crinoline sheet to the burlap canvas with watered-down gel medium. To make sure the crinoline is solidly attached, you can turn over the burlap and brush gel medium on the back. The burlap is so porous that the gel medium will soak through the fibers. Cut and adhere a few more strips of crinoline to the background as well.

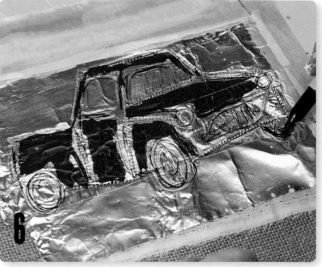

6

Add Ink Color the truck with red ink. Let dry. Take a black permanent marker and loosely draw over some of the lines that make up the truck.

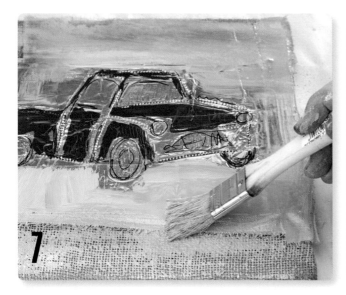

7

Paint the Background The burlap is very porous, so use a watered-down version of your acrylic paint. Then paint the background around the truck, mixing and blending colors as you go.

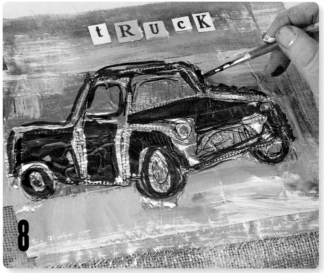

8

Outline the Truck Adhere the letter tiles to the top of the canvas with gel medium. Outline the truck with a small paintbrush and black ink. Let dry.

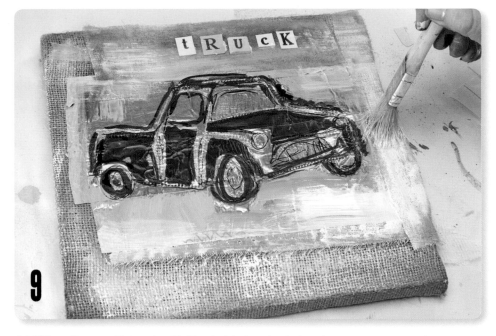

Add More Texture Using the 2" (5cm) chip brush, drybrush white gesso over the background to create texture. Let dry.

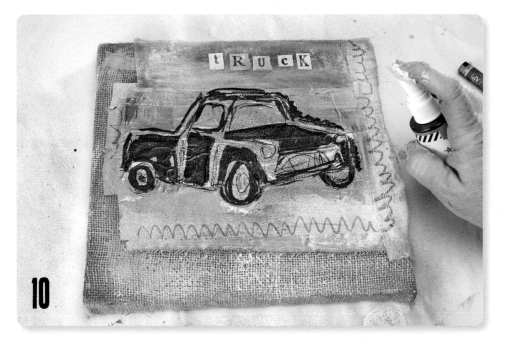

Final Details Draw a small border around the truck with a pencil. Spray the whole canvas with color shine spray to finish it.

TILE TAPE DRESS

Again, this was another hardware store find. I saw the tile tape and instantly fell in love with the loose weave and the fact that the weave was little squares (I'm usually a polka-dot girl, but I loved the squares). I knew it would be a great addition to my mixed-media stash.

For this piece it's collaged in the background, going off the canvas a bit, which I love to do. This is the perfect material for that since it is light yet very sturdy. Layering the dress with the tape adds just a bit of texture. The tape is a bit sticky so you can play around with where you want it before you use gel medium to adhere it. Then a bit of gesso picks up all those great little squares.

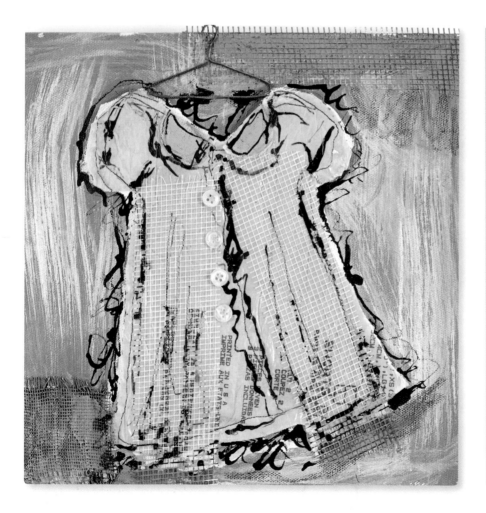

MATERIALS LIST

2" (5cm) chip brush

10" × 10" (25cm × 25cm) stretched canvas

acrylic paints and brushes

black and blue ink

crinoline

heavy matte gel medium

pencil

pipette

scissors

sewing machine and thread

small wire clothes hanger

tile tape

unprimed canvas

vintage buttons

vintage pattern paper

water-soluble oil pastels

white gesso

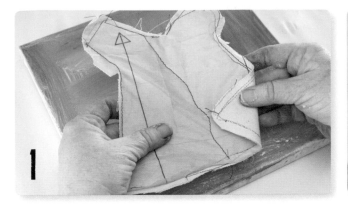

Create the Background and Dress Paint a background on the stretched canvas with acrylic paints. Let dry.

Sketch a simple dress shape on unprimed canvas. Lay a piece of pattern paper on top, and stitch the paper onto the unprimed canvas, following the outline of the dress shape. Cut out the stitched-together dress shape.

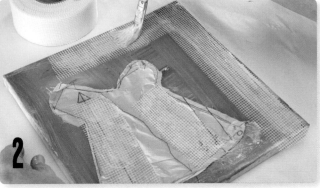

Add Tile Tape Using gel medium, adhere the dress to the canvas. Time to gritty up that dress form! Cut a few strips of tile tape in varying sizes. Collage the smaller strips on top of the dress and the longer strips along the edge of the canvas with gel medium. Let dry.

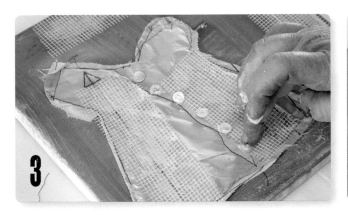

Add Button Details Place buttons down the center of the dress and adhere them with gel medium. The buttons will give the dress even more character.

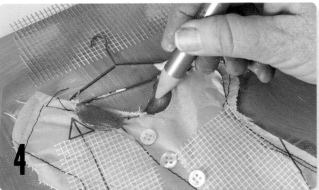

Add a Collar and Color Cut a collar shape for the dress from a scrap of crinoline. Add the collar and a small wire hanger to the canvas with gel medium. Carefully paint the crinoline collar with acrylic paint, and add some more color to the background. Then you can add more color and detail with the water-soluble oil pastels.

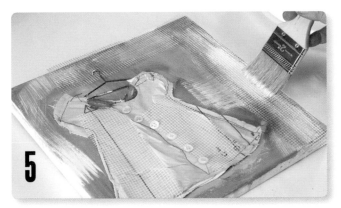

Add more Texture Drybrush white gesso over the background with a 2" (5cm) chip brush to help bring out the texture of the tile tape.

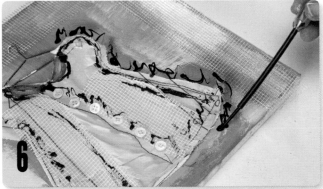

Final Details The dress needs a bit more visual interest, so now is the time to add more lines and texture with ink. Use a pipette and the black and blue ink to outline the dress. Be loose and free with your lines!

TEXTURE ADDITIVE

When texture is the name of the game, keep it simple and keep searching for mediums to add into your paint. Texture additive can be found at the hardware store and is perfect for mixing with acrylic paints.

The texture additive is a dry additive, so when you are mixing it into your paint do a little at a time. You can always add more until you are happy with the consistency. I love to use it very thick and lumpy, like a thick brownie mix! On this piece I cut the stencil shape out of a piece of cardboard, so I could lay it on thick.

SHE KNEW THERE WERE MANY WAYS TO ADD TEXTURE TO A MIXED-MEDIA PAINTING, BUT WHEN SHE WALKED INTO A HARDWARE STORE, IT WAS LIKE COMING HOME.

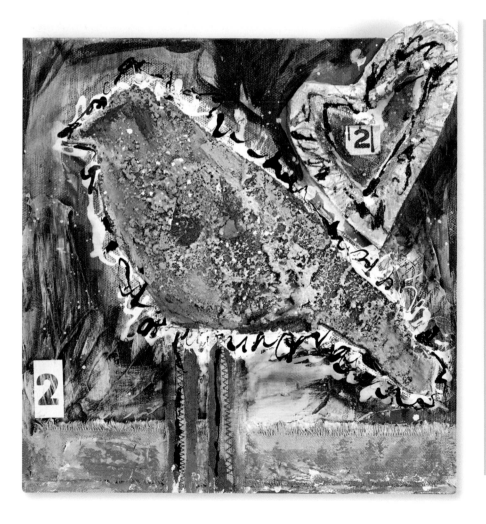

MATERIALS LIST

2" (5cm) chip brush

12" × 12" (30cm × 30cm) stretched canvas

18-gauge wire

acrylic paints and brushes

black and white ink

canvas scraps

cardboard

craft knife

heavy matte gel medium

number tiles

palette knife

pencil

pipette

texture additive for paint

water-soluble oil pastels

white gesso

wire cutter

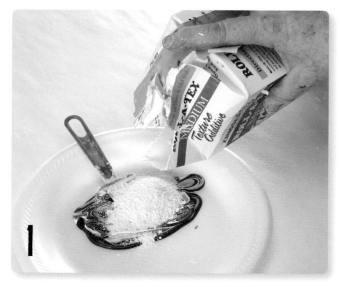

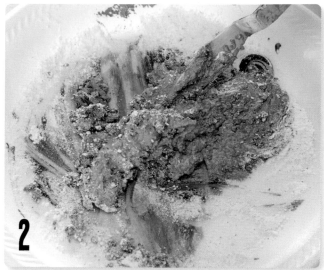

Start Mixing the Paint and Additive Mix some acrylic paint to get the desired shade. Then start adding the texture additive to the paint and mix it all together.

Keep Mixing Keep mixing together the paint and additive until you have a pretty thick paste with good texture.

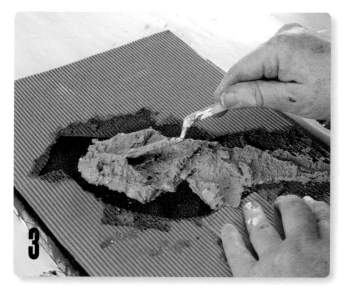

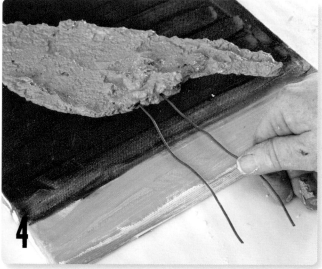

Apply the Mixture Draw a bird shape onto a piece of cardboard and cut it out to create a stencil. Lay the stencil on a prepared canvas, and apply the texture paint mixture. It's easiest to spread the mixture with a palette knife, but if you don't have a palette knife, you can use your fingers. Apply a thick mixture to give the bird dimension. Carefully lift the stencil away to reveal the bird shape.

Add Wire Legs After removing your stencil, cut two pieces of 18-gauge wire for the legs. Place the wires into the texture mixture while it's still wet. Apply more of the texture mixture on the points of attachment to better secure the legs. Let dry.

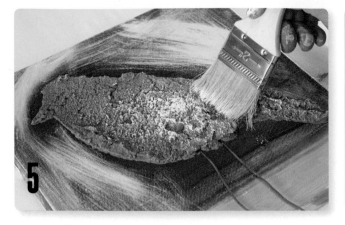

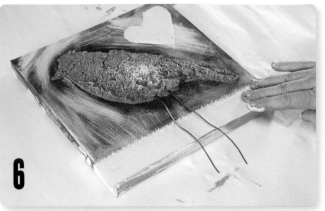

Drybrush Gesso Once the mixture has dried, drybrush white gesso onto the background and the bird with a 2" (5cm) chip brush.

Add Canvas Shapes Cut out a heart shape from unprimed canvas. Tear a small strip of canvas for the bottom of the painting as well. Tearing the canvas rather than cutting it provides a frayed (and more textured) edge. Attach both canvas pieces with gel medium.

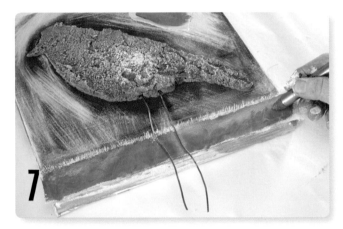

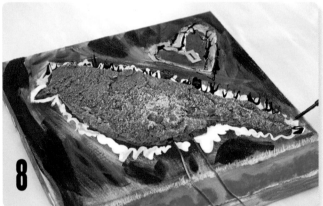

Add Color Paint both the heart and the canvas strip with acrylic paint. While the paint is still wet, add more texture and color with water-soluble oil pastels.

Outline the Bird and Heart Add more layers of acrylic paint to the background around the bird. Outline the bird and heart with white and black inks. Adhere a number tile in the middle of the canvas heart with gel medium.

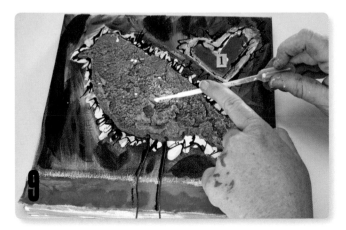

Final Details Add a little more color to the bird with the pastels and paint. Then fill the pipette with white ink and gently tap it to splatter the ink on top.

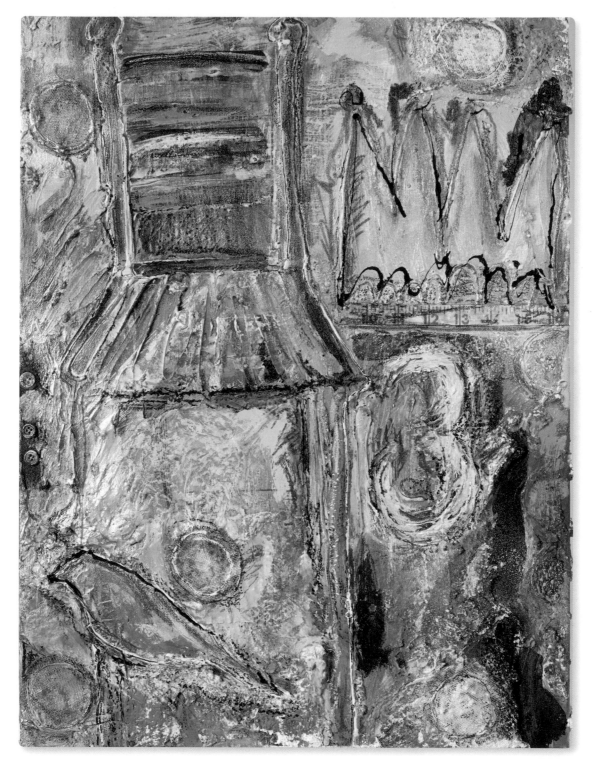

Blue Chair

For this piece, the bird in the lower lefthand corner was created using a cardboard bird stencil and the texture additive. It is the opposite of the other bird piece because in this section of the painting the stencil shape was the bird, and then I applied the additive *around* the bird. So the bird is actually just the painted canvas and the texture is around it.

LIQUID NAILS DRESS

Liquid Nails is a construction adhesive found in most hardware stores. If you were using it as intended, you would use a caulking gun to apply the adhesive. I was looking for a material to submerge fabric and dresses into, something that would have a wet consistency but dry the fabric rock hard. I also like the fact that it has to dry overnight, so you have some time to play with the fabric and create pleats and folds. So while looking at products, the name itself, Liquid Nails, led me to believe it would be just the nontraditional material I was looking for. I was right!

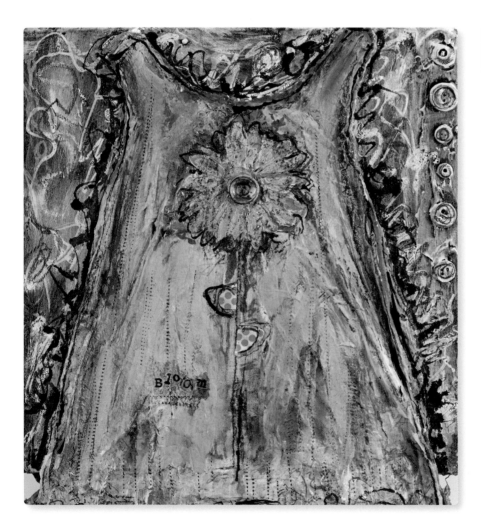

MATERIALS LIST

2" (5cm) chip brush

6B graphite crayon

12" × 12" (30cm × 30cm) stretched canvas

acrylic paints and brushes

black and white gesso

black ink

bubble wrap

canvas or paper flower

carbon paper

gallon-size plastic bag

heavy matte gel medium

label maker

Liquid Nails

pipette

stitched crinoline

tracing wheel

vintage buttons

vintage doll dress

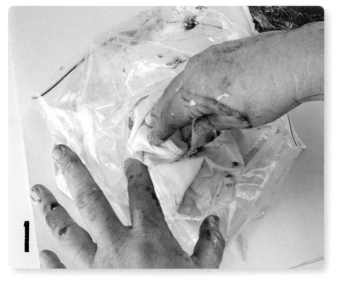

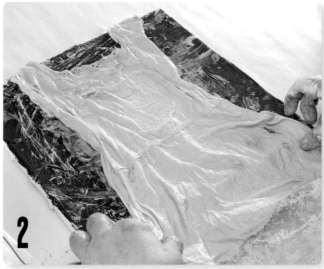

Submerge the Dress in Liquid Nails Squeeze the tube of Liquid Nails into a gallon-size plastic bag. Add about a half a cup of water. Submerge the dress in the bag of Liquid Nails, moving it around in the bag so it is completely covered. You want the dress covered, but wring it out in the bag so any excess liquid drips off.

Arrange the Dress on the Canvas Lay the wet dress onto the prepared canvas and begin to shape it. Play with the placement of your dress. It will harden as the Liquid Nails dries but for now it's pliable. Add folds and pleats to create texture and volume. It will harden in whatever shape you desire.

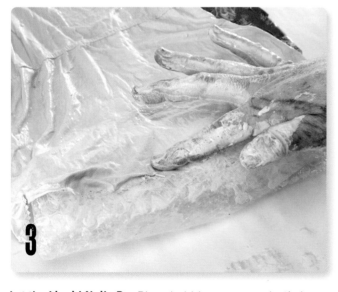

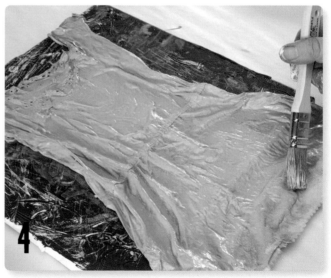

Let the Liquid Nails Dry Place bubble wrap or a plastic bag underneath any pieces of fabric that are hanging off the canvas. This will help hold it in place and help it harden into the shape you want. It's best to let the Liquid Nails dry overnight. You may have to let it dry even longer if it hasn't completely hardened by the next day.

Add Color Once dry, use acrylic paint to add the first layer of color onto the dress. Try to get paint into the folds of the fabric. Let dry.

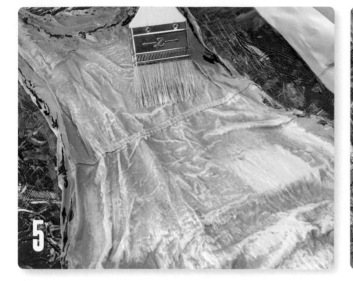

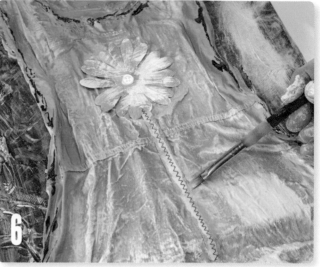

Add Texture Once the acrylic paint is dry, paint white gesso on top with the 2" (5cm) chip brush to highlight the folds and texture of the dress. Outline the edge of the dress using a pipette and black ink.

Add Flower Detail Cut a flower shape out of paper or canvas and paint it with acrylic paint. Attach the painted flower to the dress with gel medium. Add a button to the center of the flower. For the stem of the flower, use a thin strip of crinoline with a zigzag stitch. Attach the stem to the dress with gel medium. Then paint the edges of the crinoline stem the same color as the dress to blend it.

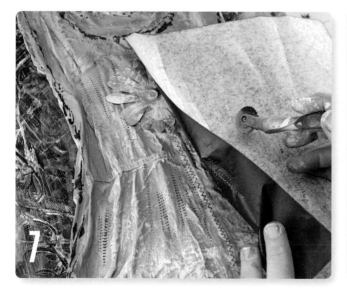

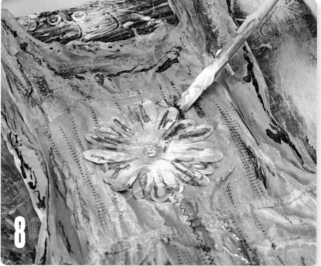

Add More Texture It's time to make the dress gritty. Apply lines of texture to the dress by rolling a tracing wheel over carbon paper. Press firmly to transfer the lines. Add as many lines as you want.

Set the Graphite in Place Use a 6B graphite crayon to scribble and add shading to the folds of fabric. With a paintbrush dipped in water, smooth and spread the graphite. Then paint over the graphite with a little bit of gel medium mixed with water to help set the graphite in place.

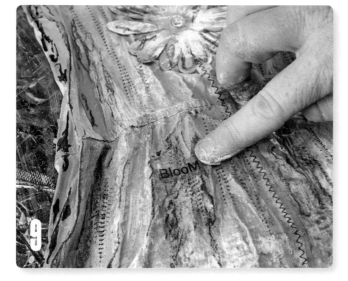

Add Text Using the label maker, type and print your desired word or phrase. Then adhere it to the dress with the gel medium.

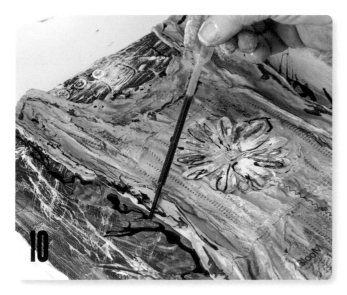

Final Details Add any other layers of color and grit that you want. Then finish the piece by outlining the dress with the pipette and black ink. Keep your lines loose!

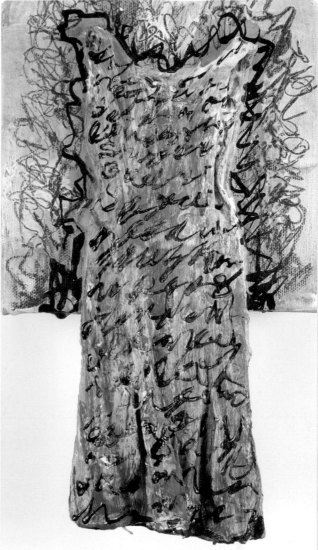

She Wore the Write Dress

Although the technique is the same here, I wanted to experiment to see if I could have a dress hang off the canvas several inches. I hung the canvas (this is a wide-edge 6" × 6" [15cm × 15cm] canvas) on the wall of my studio and adhered the dress to the canvas, taking extra care in making sure the top of the dress was adhered to the canvas with a very thick layer of Liquid Nails (I used my fingers to apply an extra amount around the dress edges). I let the dress dry overnight with the bottom hanging off but not touching the wall. The next day the dress was totally adhered to the canvas and the bottom of the dress that had been submerged in the Liquid Nails was rock hard!

ART PLASTER SWEATER

Art plaster is purchased with the sculptural materials at an art store. When it dries it is stronger than regular Plaster of Paris, which I have used for this technique before. Plaster of Paris tends to chip. Art plaster is going nowhere: no chipping, no breakage. The beautiful thing about art plaster is the setting time. If you dip a sweater or fabric into it, it dries very quickly, unlike Liquid Nails, which will need to dry overnight. It also has a chunkier look to it, which is why I started dipping sweaters into it. It will be dry enough in about a half an hour to start painting on it. If it is a bit damp, the paint will soak into the plaster though, leaving you with a smooth sheen. If parts of the clothing/fabric are off the canvas, make sure you prop them up with plastic so they dry the way you want them to dry.

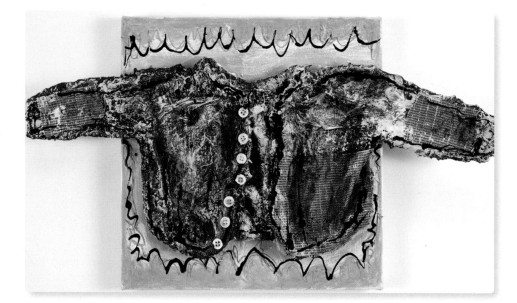

MATERIALS LIST

2" (5cm) chip brush

12" × 12" (30cm × 30cm) stretched canvas

acrylic glazes

art plaster

black ink

crinoline

heavy matte gel medium

paintbrushes

pencil

pipette

resealable plastic bag

sweater

vintage buttons

vintage pattern paper

water-soluble oil pastels

white gesso

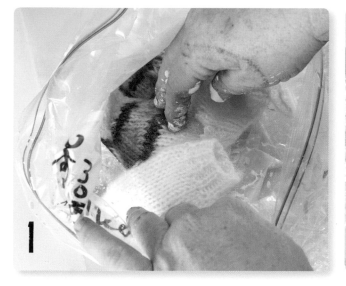

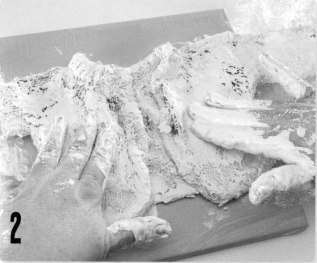

Mix the Art Plaster Mix the art plaster with water per the manufacturer's instructions. Then put the art plaster into a resealable plastic bag. Dip the sweater in the bag, making sure to entirely cover it with the art plaster. Squeeze any excess plaster back into the bag.

Add the Sweater to the Canvas Arrange the sweater onto a prepared canvas. Add more plaster to the top of the sweater with your fingers so the whole sweater is covered. However you shape the sweater now will be how it stays once it's dry. Let the plaster dry for a couple hours.

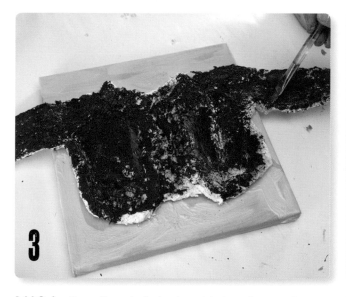

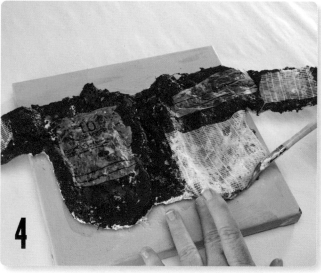

Add Color Once the art plaster has dried, make sure the sweater is adhered to the canvas. If the plaster wasn't enough to hold the two together, use gel medium to adhere the sweater. Paint the first layer of color on the sweater with a red acrylic glaze. Let dry.

Collage Paper and Crinoline Once the first layer of color is dry, cut strips of crinoline and pattern paper. Collage them onto the sweater with watered-down gel medium.

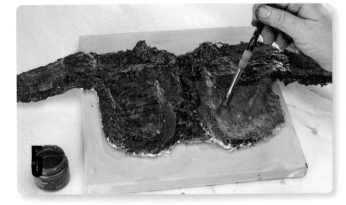

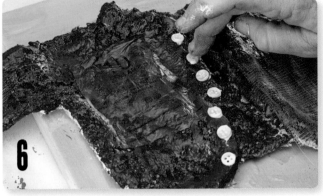

Add More Color Choose a similar color to layer onto the sweater next to help the collaged pieces blend in. In this case, I chose a pink glaze to go over the red. Paint the next layer of color over the sweater and the collaged pieces. Let dry.

Add Button Detail Adhere a row of buttons down the center of the sweater using gel medium. Let dry.

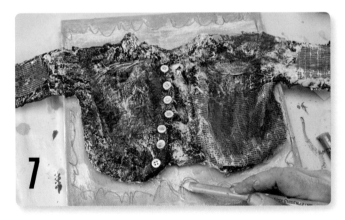

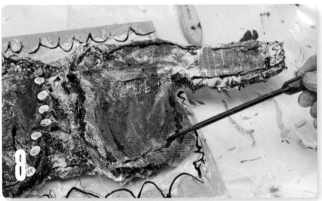

Add Texture Drybrush white gesso over the whole sweater with a 2" (5cm) chip brush. At this point you can also use water-soluble oil pastels to add more color and texture to the sweater. Add more color to the background as well. With a pencil, draw into the pastel background to create a border. Let everything dry.

Final Details Outline the sweater with a pipette and black ink. Add texture lines and drops of ink randomly on top of the sweater to finish the piece.

FINDING CLOTHES

The clothes for these projects can often be found at flea markets or thrift stores. Look for kid clothes or outfits for dolls or teddy bears.

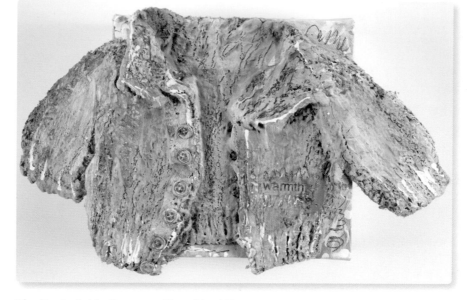

The Periwinkle Sweater Kept Her Warm

The sweaters I use are actually not little cardigans. They are sweaters for dolls or teddy bears. Before I dip them, I cut up from the bottom all the way through to the neck, turning it into a cardigan! After dipping the sweater, fold down the collar and shape it. Voilá, a cardigan! I have had some luck purchasing vintage doll cardigans on eBay, but they are few and far between.

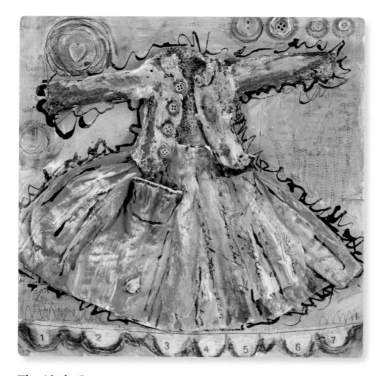

The Little Sweater

The variation here of the sweater and skirt are vintage doll clothes I purchased. Art plaster is not just for sweaters! Be creative and try new combinations.

VISIT CREATEMIXEDMEDIA.COM/COLLAGEPAINTDRAW FOR BONUS DEMONSTRATIONS!

WIRE ON CANVAS

For this piece you can create the bird shape from a piece of heavy cardboard or cut it from a thin piece of wood. I think it makes a difference if the bird shape has some dimension to it. As the piece began with the bird, that was the first thing adhered to the canvas with gel medium. It's time to get your wire on! Using the wire to create the cage shape adds a lot of dimension to this piece.

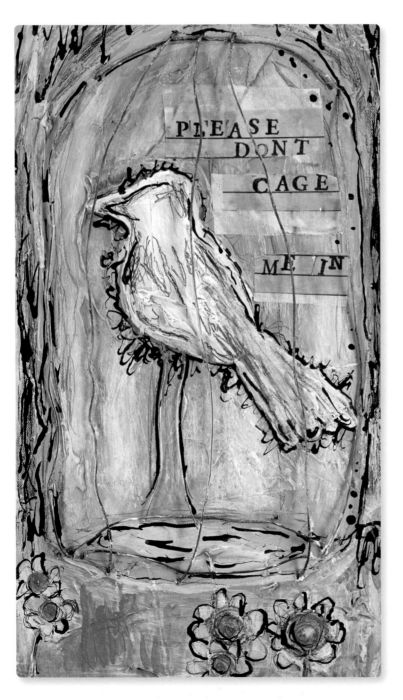

MATERIALS LIST

1" (2.5cm) chip brush

2B and 4B graphite crayon

12" × 12" (30cm × 30cm) stretched canvas

18-gauge wire

acrylic paints and brushes

awl or small screwdriver

black ink

heavy cardboard

heavy matte gel medium

ink pad

letter stamps

modeling paste

palette knife

pinking shears

pipette

tissue paper

vintage pattern paper

white gesso

wire cutters

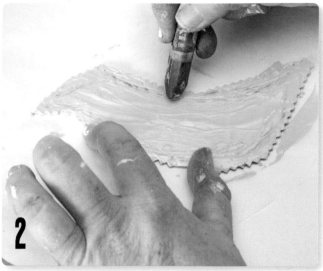

Create the Bird Cut a bird shape from a piece of cardboard. You can use pinking shears to cut a textured edge. Gesso the cardboard to prime it. Once the gesso is dry, cover it with acrylic paint. A bright yellow hue is perfect for a bird.

Add Texture While the acrylic paint is still wet, draw an outline on the bird shape with a 2B graphite crayon to add texture. Let dry.

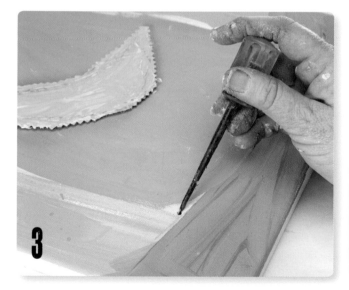

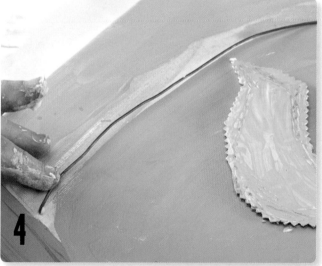

Create Holes for the Wire Using a 1" (2.5cm) chip brush, block out the painting by adding color to the background and loosely defining the birdcage shape. Let dry. Adhere the cardboard bird to the canvas with gel medium. With an awl or a small screwdriver, carefully punch a small hole in the canvas at the bottom of the painted birdcage.

Start Building the Wire Cage Cut various lengths of 18-gauge wire for the cage. Slip the bottom end of the wire through the small hole you created with the awl. Dab a little gel medium on top to help keep it in place. You can also put gel medium on the back of the canvas where the wire pokes through. Dip the top end of the wire into the gel medium as well. Press this end firmly to the top of the canvas to help it stick. You can always add more gel medium to these points of attachment for security.

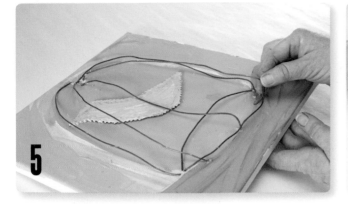

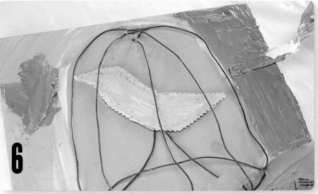

Finish the Wire Cage Use the awl to carefully create the rest of the holes for your cage wires. Continue adding wire pieces to the canvas to build the birdcage shape.

Build Up the Background Add two small pieces of wire with gel medium for the bird's legs. Next, work on the background. Collage some strips of pattern paper onto the bottom of the canvas with modeling paste. Mix acrylic paint and modeling paste to create a thicker medium and spread this onto the background with a palette knife. Let dry.

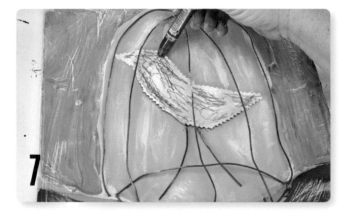

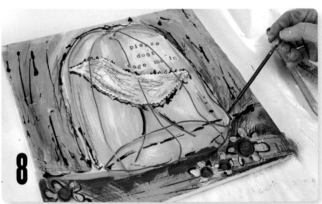

Add More Texture Once the paint is dry, lightly drybrush white gesso onto the canvas background and between the wires. Add feather lines to the bird with a 4B graphite crayon.

Final Details Stamp your desired phrase onto tissue paper. Trim this down and collage it inside the birdcage with gel medium. The bottom of the canvas is a bit plain. Add a few flowers at the base of the canvas with acrylic paint. Finish the piece by outlining the flowers, bird and cage with the pipette and black ink.

REWORKING A PIECE

Always know that you can rework a piece if something doesn't feel quite right. When this piece was almost complete, I felt it needed something across the bottom of the painting. So I added a thin layer of paste and drew in the flowers. Heed your intuition when you are creating. If you feel like a piece needs something, you can always go back into it.

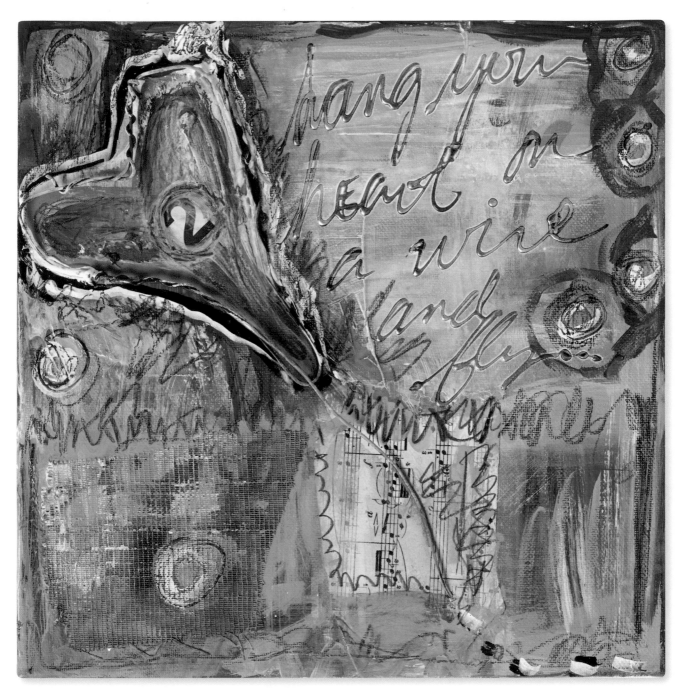

Heart Wire
A variation of the wire birdcage piece, this piece reminds me of a heart-shaped balloon. It seemed natural to have the heart stay attached to the wire, almost floating off the canvas.

CLOTHESPIN FOUND OBJECTS

I had originally thought this piece was going to have many found objects adhered to the background, but once I added the clothespins I knew that was enough. Often one of the hardest parts of creating a piece of art is knowing when to stop. Listen to what your heart is telling you; often you will just know. Sometimes less *is* more.

THANK GOODNESS SHE FOUND ANOTHER WAY TO USE CLOTHESPINS, ALTHOUGH THERE IS SOMETHING TO BE SAID FOR HANGING SHEETS OUTDOORS.

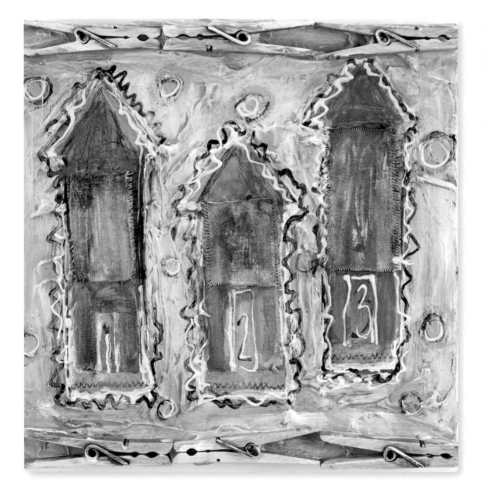

MATERIALS LIST

2" (5cm) chip brush

10" × 10" (25cm × 25cm) stretched canvas

acrylic paints and brushes

brown and white fabric paints

canvas scraps

heavy matte gel medium

modeling paste and spreader

pencil

rectangle and triangle shapes for stencil

vintage clothespins

water-soluble oil pastels

white gesso

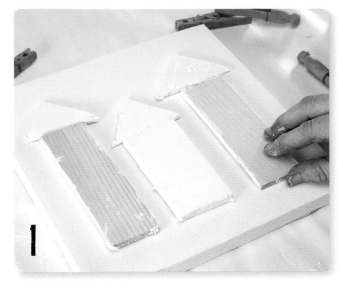

Create the Houses Use wood and foam core shapes to create houses that can be used as stencils. Place the house shapes where you want them on the canvas.

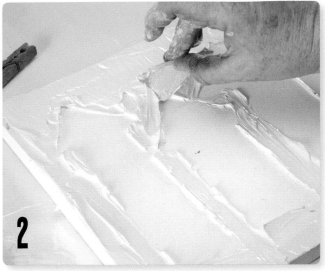

Apply Modeling Paste Apply a thick layer of modeling paste, almost like grout, onto the canvas and around the houses, making sure that the stencils stay in place. Use a smaller paintbrush to add the paste all the way up to the edges of the houses. Carefully lift the stencils off the canvas. Clean up the edges if needed.

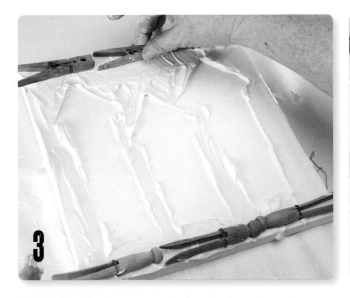

Add Clothespins Place your clothespins into the wet modeling paste for a border at the top and bottom of the canvas. Press them securely into the wet paste. Then let the modeling paste dry.

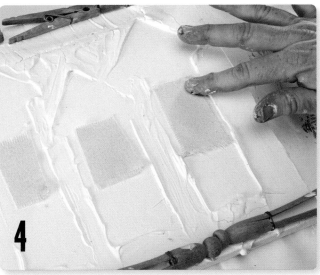

Add Canvas Cut strips of canvas to fit into each house and adhere them to the piece with gel medium.

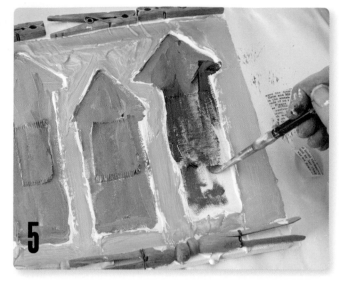

Add Color Paint the first layer of background color with acrylic paint. Then start filling in the house shapes, painting over the canvas strips.

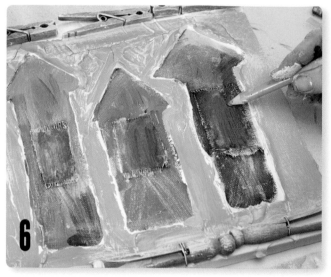

Continue Building Layers Use water-soluble oil pastels to add more color to the canvas strips. Then scribble into the pastel with a pencil to create texture. Drybrush white gesso onto the background and over the clothespins with a 2" (5cm) chip brush. Continue to build up the layers of color.

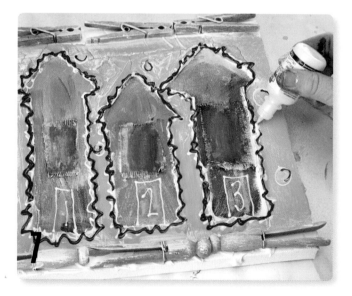

Final Details Add a small block of color in each house for doors. Outline the house shapes and the doors with white and brown fabric paint. Then draw the house numbers using the white fabric paint. You can also add fun details, like small circles, in the background. Play with it and do what feels right to you!

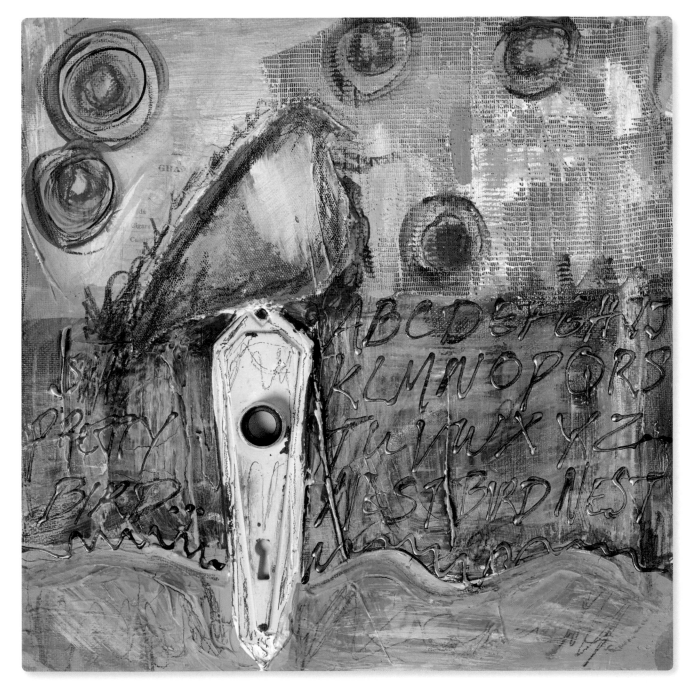

Keyhole Bird

Scrounging around a consignment shop a couple years ago, I came across a stack of vintage keyholes. Knowing they would come in handy one day, I picked them up. The inspiration for this piece came from the actual object. The keyhole reminded me of a perch for a bird. Let the objects you find speak to you.

INDEX

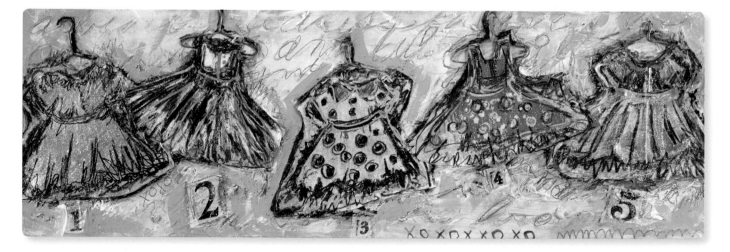

RESOURCES

Art Supply or Hobby and Craft Stores:
Acrylic glazes, acrylic ground medium, acrylic paint, art plaster, fabric paint, gesso, graphite crayons, heavy matte gel medium, modeling paste, painting surfaces (canvas and panel), palette knife, sludge, water-soluble oil paints and pastels and more.

Fabric Stores:
Burlap, buttons, canvas, cheesecloth, crinoline, lace, scrim, tracing wheel

Hardware and Home Improvement Stores:
Canvas drop cloths, ceiling glitter, chip brushes, HVAC or heavy aluminum tape, Liquid Nails, Plaster of Paris, small brad nails, texture paint additive, tile backer tape, various gauge wire

Office Supply:
Carbon paper

Pipette Source:
Enasco.com

Stencils:
Stencilgirlproducts.com

ABOUT SUE PELLETIER

Sue Pelletier is an artist, mother and teacher, not always in that order. She has taught elementary school art in Dover, Massachusetts for twenty-five years. The spontaneity and expression in children's art has always been an inspiration. Sue has a BA from Saint Michaels College in Vermont, where she majored in fine arts and elementary education and an MFA from the Pratt Institute in New York, where she majored in painting.

She has been published several times in *Cloth Paper Scissors,* as well as in *Somerset Studio* and various other Stampington magazines. Sue's artwork has been on four magazine covers. She also has two DVDs out with Interweave, featuring textural surfaces and innovative ways to use mediums in your art. Sue teaches online classes, and she teaches internationally with mixed-media events including *Create* and *Art Is You*, as well as smaller, more intimate venues in studios and shops around the country. She has also been a guest columnist for CreateMixedMedia.com.

Please check out her blog for more bits and pieces of her work and life: www.suepelletierlaughpaint.com.

She can also be found on Facebook as Sue Pelletier and Sue Pelletier art.

ACKNOWLEDGMENTS

I would like to thank Pokey Bolton, who, as the editor for *Cloth Paper Scissors* some years ago, called me on the phone one day after I had submitted work and said, "So what is your story?" I remember thinking, *What* is *my story?* So I told her. Little did I know that my story would change over the years in huge ways, but my story has always included creating art as often as I can.

Thank you to my students, both the adults and the children I have taught over the years, for helping me realize everyone is an artist. Often all one needs to get started is guidance and heavy matte gel medium. Much love to Ellen and Sal of the amazing tribe that is *Art is You* for embracing me into their community and giving me a last-minute teaching spot many years ago when I needed it most.

xoxox,
Sue

DEDICATION

This book is dedicated to my two children, Connor and Harlyjane, because the greatest pieces of art I ever created are these two. They are unique individuals, true to themselves, who have always accepted the fact that their mother would most likely show up at school and social events with paint on her hands and in her hair.

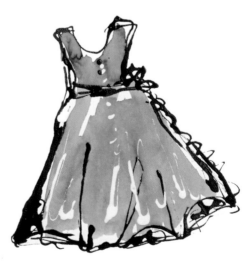

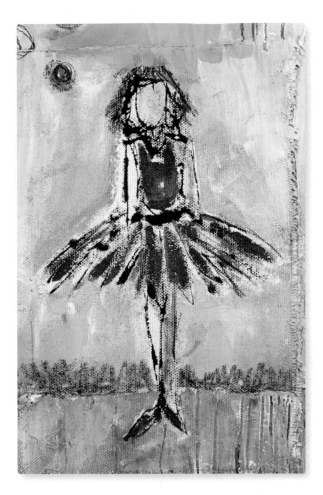

fw
a content + ecommerce company

Other fine North Light Books are available from your favorite bookstore, art supply store or online supplier. Visit our website at fwmedia.com.

19 18 17 16 15 5 4 3 2 1

DISTRIBUTED IN CANADA BY FRASER DIRECT
100 Armstrong Avenue
Georgetown, ON, Canada L7G 5S4
Tel: (905) 877-4411

DISTRIBUTED IN THE U.K. AND EUROPE
BY F&W MEDIA INTERNATIONAL LTD
Brunel House, Forde Close, Newton Abbot, TQ12 4PU, UK
Tel: (+44) 1626 323200, Fax: (+44) 1626 323319
Email: enquiries@fwmedia.com

DISTRIBUTED IN AUSTRALIA BY CAPRICORN LINK
P.O. Box 704, S. Windsor NSW, 2756 Australia
Tel: (02) 4560-1600; Fax: (02) 4577 5288
Email: books@capricornlink.com.au

ISBN 13: 978-1-4403-3702-4

Edited by Beth Erikson
Designed by Elyse Schwanke
Production coordinated by Jennifer Bass

METRIC CONVERSION CHART

To convert	to	multiply by
Inches	Centimeters	2.54
Centimeters	Inches	0.4
Feet	Centimeters	30.5
Centimeters	Feet	0.03
Yards	Meters	0.9
Meters	Yards	1.1

laugh out loud

Ideas. Instruction. Inspiration.

Receive FREE downloadable bonus materials when you sign up for our free newsletter at artistsnetwork.com/Newsletter_Thanks.

Find the latest issues of *The Artist's Magazine* on newsstands, or visit ArtistsNetwork.com.

These and other fine North Light products are available at your favorite art & craft retailer, bookstore or online supplier. Visit our websites at ArtistsNetwork.com and ArtistsNetwork.tv.

f Follow North Light Books for the latest news, free wallpapers, free demos and chances to win FREE BOOKS!

Visit ArtistsNetwork.com and get Jen's North Light Picks!

Get free step-by-step demonstrations along with reviews of the latest books, videos and downloads from Jennifer Lepore, Senior Editor and Online Education Manager at North Light Books.

Get involved
Learn from the experts. Join the conversation on